DAD,
MERRY CHRISTMAS
FROM THOSE OF
US WHO
LOVE YOU.
JOE + MYRA 1992

Earth, water, and sky were here in the beginning of time. Grandmother Moon is guardian of the night, and Father Sun is guardian of the day.

DANCING COLORS

PATHS OF NATIVE AMERICAN WOMEN

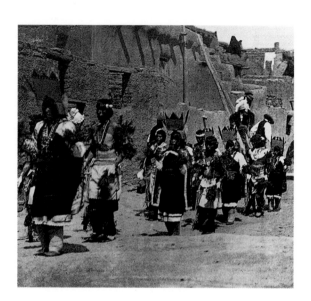

Introduction by C.J. Brafford and Captions by Laine Thom
Designed and Produced by McQuiston & Partners

Chronicle Books • San Francisco

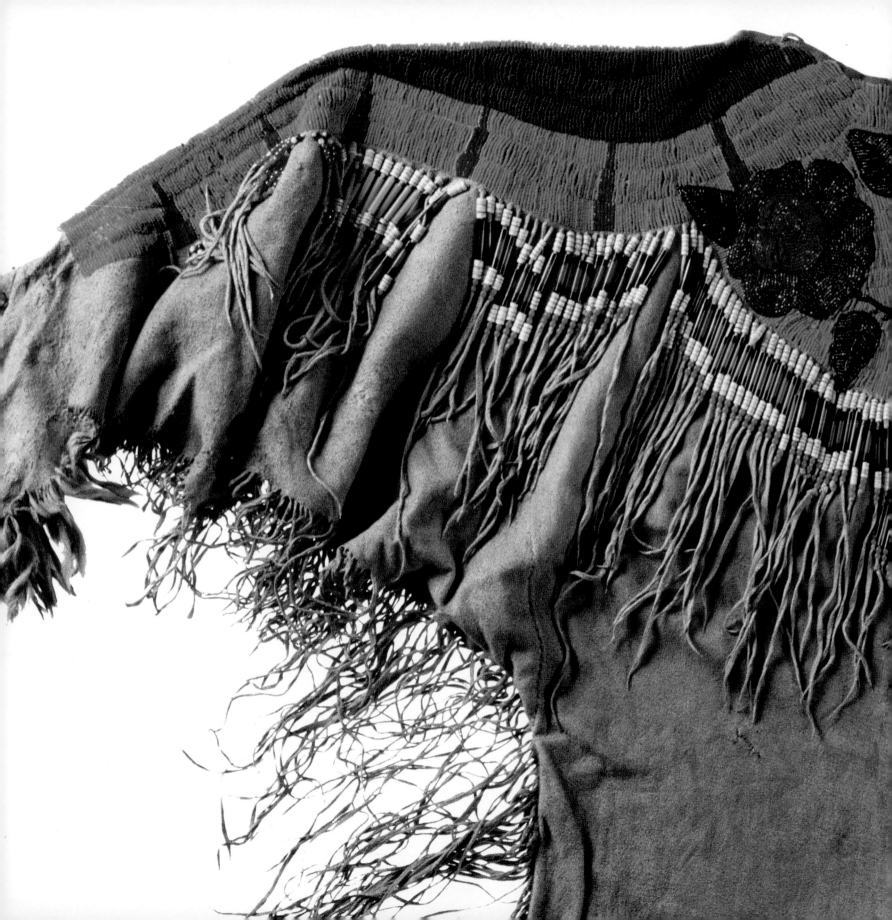

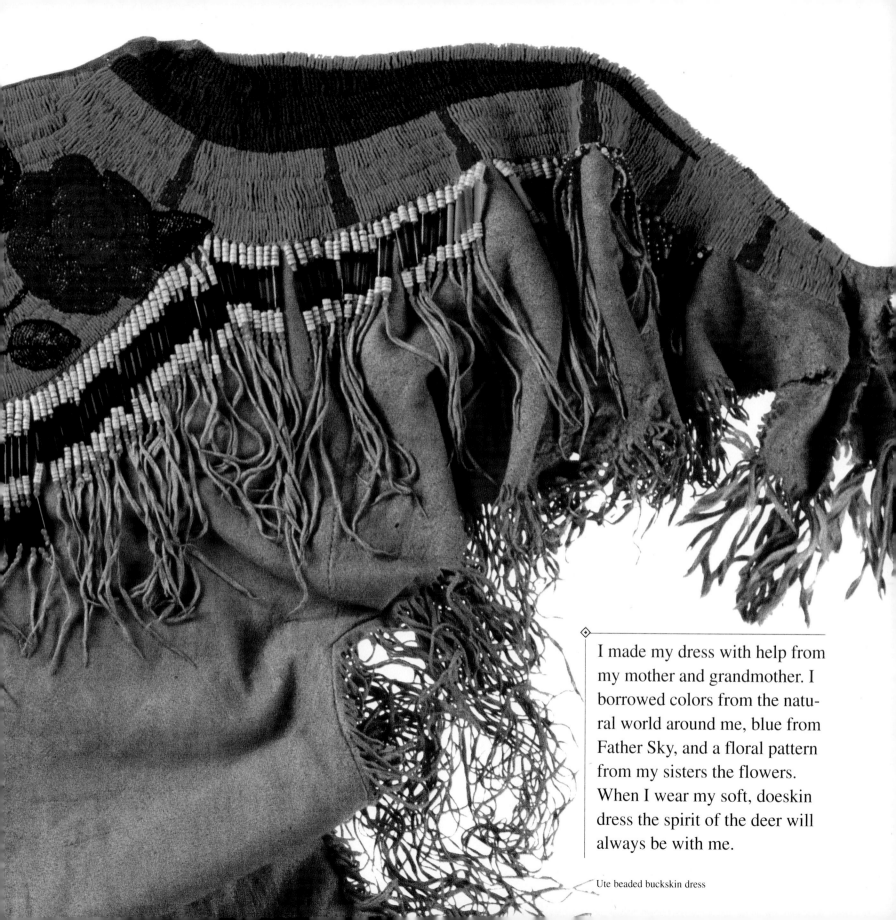

I made my dress with help from my mother and grandmother. I borrowed colors from the natural world around me, blue from Father Sky, and a floral pattern from my sisters the flowers. When I wear my soft, doeskin dress the spirit of the deer will always be with me.

Ute beaded buckskin dress

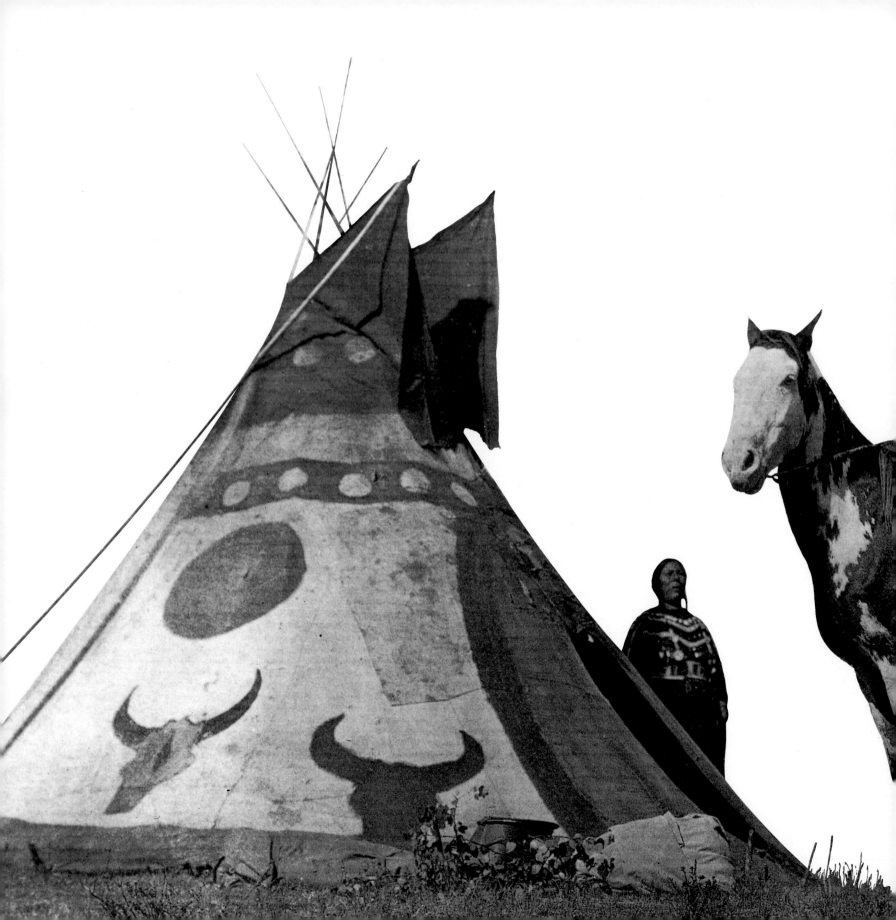

CONTENTS

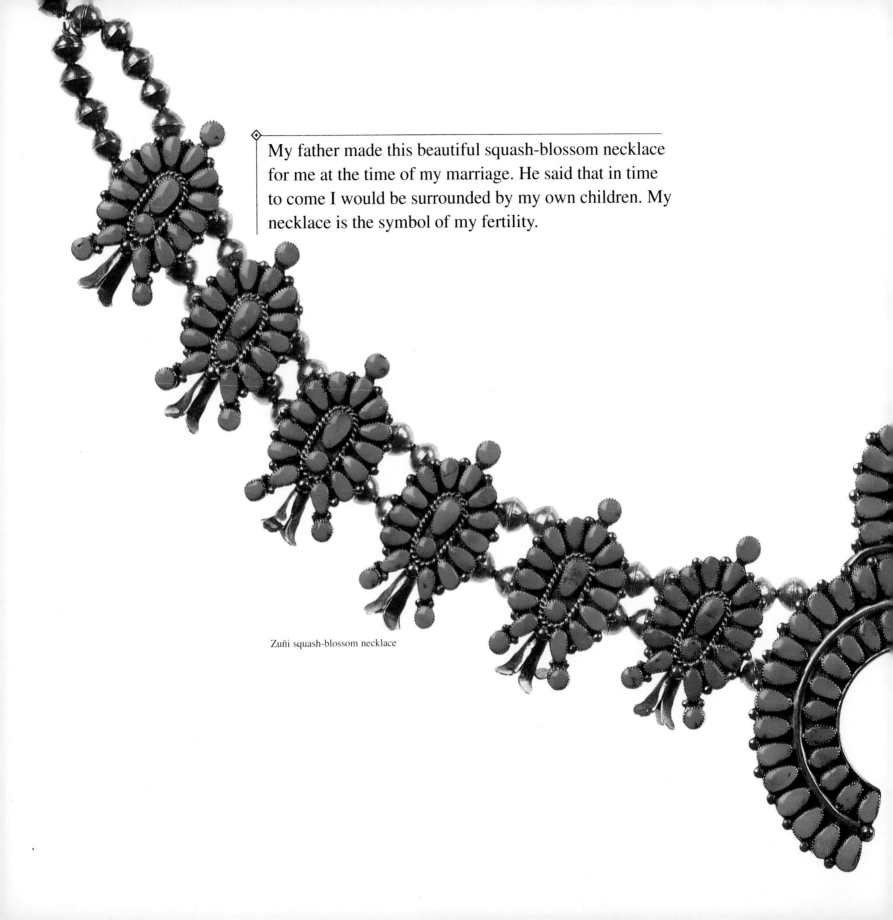

My father made this beautiful squash-blossom necklace for me at the time of my marriage. He said that in time to come I would be surrounded by my own children. My necklace is the symbol of my fertility.

Zuñi squash-blossom necklace

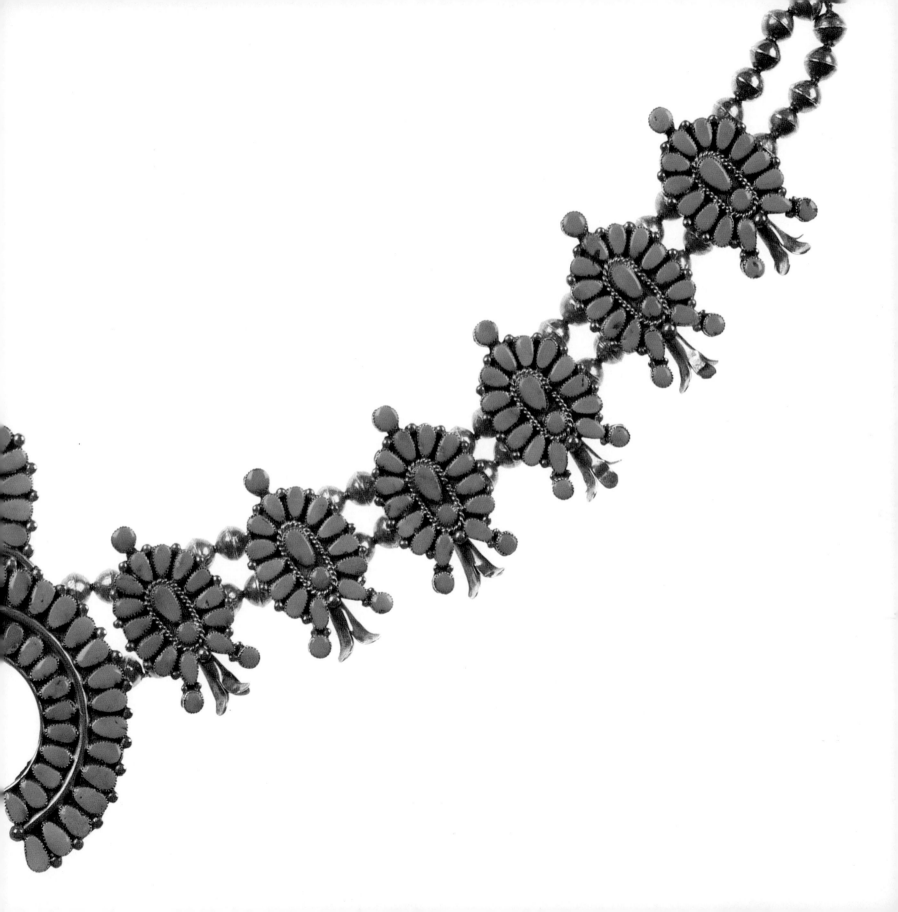

To Grace Johnson

I would like to acknowledge Sharlene Milligan, Executive Director, Grand Teton Natural History Association; Bill Swift, Chief Naturalist; and the Ranger Naturalist staff at Colter Bay Indian Arts Museum at Grand Teton National Park, Wyoming. I would especially like to thank Grace Johnson, Assistant Curator at the San Diego Museum of Man, for her patience and cheerfulness while helping us select many of the artifacts and historical images in this book, and to Stefani Salkeld, Ken Hedges, Chris Bentley, and all the staff at the San Diego Museum of Man. Many thanks to Jack Jensen, Lesley Bruynesteyn, and Michael Carabetta of Chronicle Books for their continual support, and to Joyce Sweet and Don McQuiston for inviting me to participate in this project. I would like to acknowledge my mother, Thelma Brafford; sister Debbie Winstead; and all mothers who in their humble ways walk in beauty with mother earth.

— C.J. Brafford

Produced by McQuiston & Partners, Del Mar, California; art direction by Don McQuiston; design by Don McQuiston & Joyce Sweet; editing by Julie Olfe; artifact photography by John Oldenkamp, Carin Howard, and Cynthia Sabransky; Printed in Hong Kong by Dai Nippon Printing Co., Inc.

Library of Congress Cataloging-in-Publication Data

Dancing colors: paths of Native American women/introductory material by C.J. Brafford; pictorial commentary by Laine Thom.
 p. cm.
 Includes index.
 1. Indians of North America—Women.
 2. Indians of North America—Legends.
 3. Indians of North America—Material culture. I. Brafford, C.J., 1959–. II. Thom, Laine, 1952–.
E98.W8D36 1992 92-1025
305.48'897—dc20 CIP
ISBN 0-8118-0235-3 (hard).
ISBN 0-8118-0165-9 (pbk).
10 9 8 7 6 5 4 3 2 1

Distributed in Canada by Raincoast Books
112 East Third Avenue
Vancouver, British Columbia V5T IC8

Chronicle Books
275 Fifth Street
San Francisco, California 94103

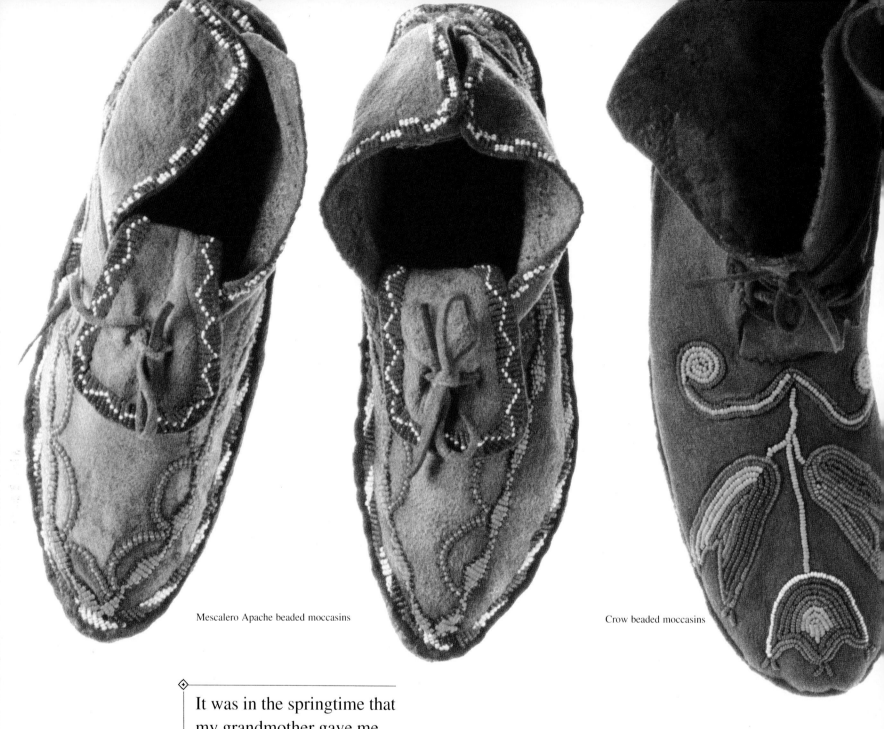

Mescalero Apache beaded moccasins

Crow beaded moccasins

It was in the springtime that my grandmother gave me her name, Flower Dancing in the Wind. I will be known by her name after she is gone. She also gave me her beaded moccasins

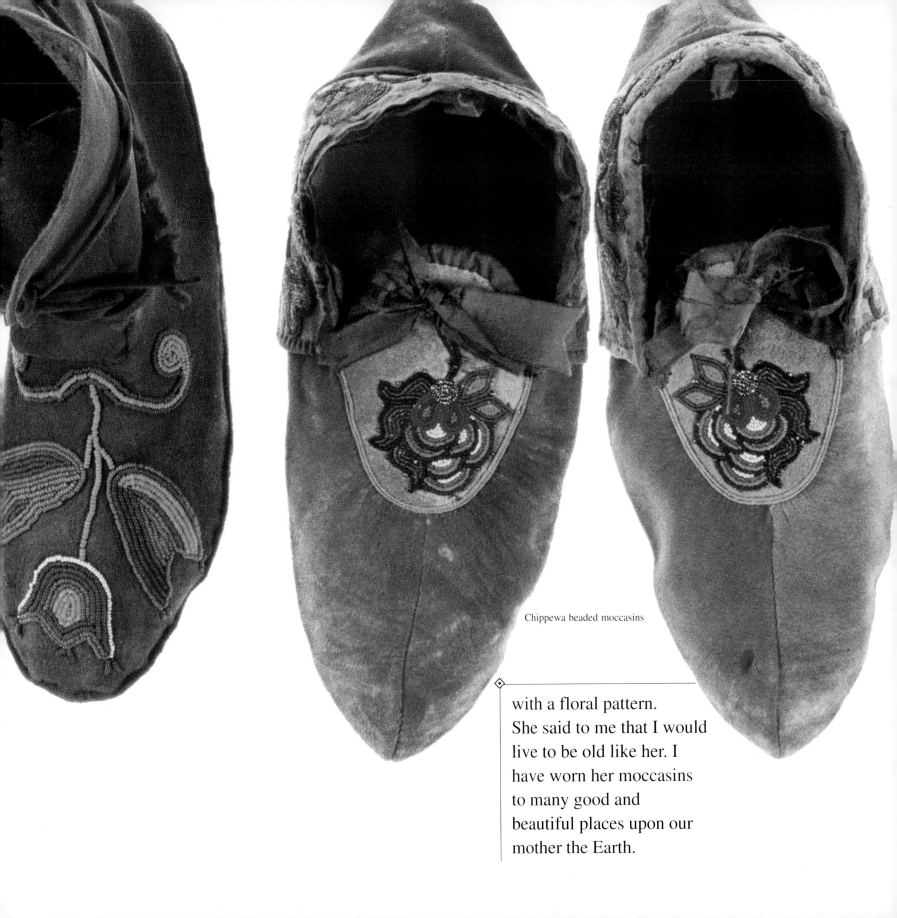

Chippewa beaded moccasins

with a floral pattern.
She said to me that I would
live to be old like her. I
have worn her moccasins
to many good and
beautiful places upon our
mother the Earth.

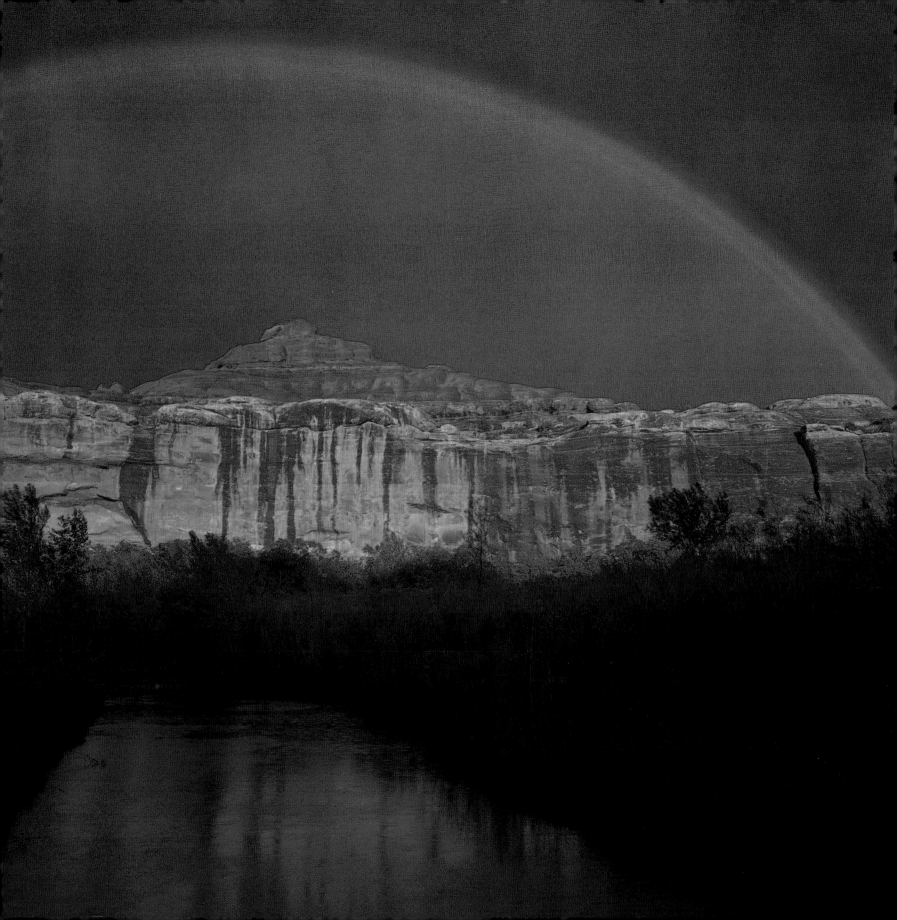

▲▲▲▲▲▲▲▲▲▲▲▲▲▲▲▲▲▲▲▲▲▲▲▲▲▲▲▲▲▲▲▲▲▲

THE CIRCLE
OF LIFE

INTRODUCTION

After the flowers have bloomed
they arch across the sky.

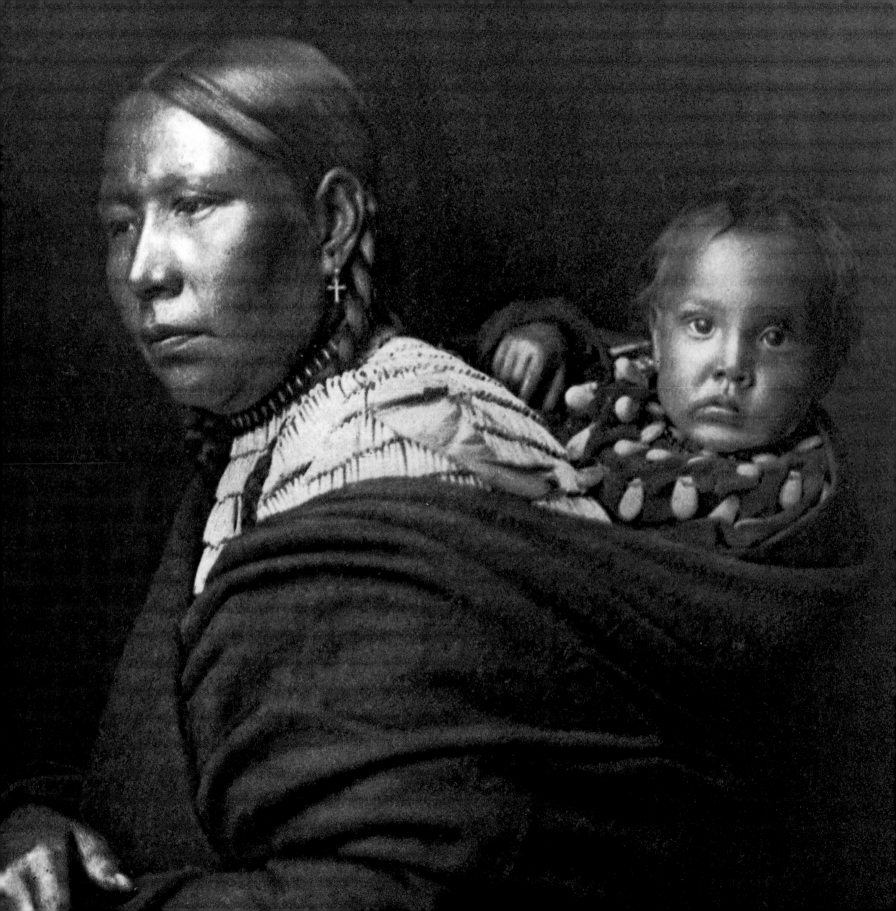

THE CIRCLE OF LIFE: INTRODUCTION

By C. J. Brafford

As a Lakota woman from the Great Sioux Nation, I began my circle of life in 1959. Born a half-breed on the Pine Ridge Indian Reservation in South Dakota, I grew up often wondering about my ancestors and the old way of life. When I was in my early twenties, an uncle gave me the Sioux name Kimimi La (Butterfly). I am learning and carrying on the spiritual values taught to me by elders through their echo memories, traditions, and beliefs. Throughout the generations of life, some traditions have been buried with our ancestors, but we still continue to observe the custom of storytelling. Stories begin with the first beginning — creation. From generation to generation Indian people share a story of how they came to Mother Earth. We all journey the four directions, traveling the full circle and believing all things have life and a spirit.

It is a never-ending circle of life for women from childhood through puberty, womanhood, and old age. According to tradition, if you see a falling star a Sioux is born.

A child is born, and life begins within the circle of the family. The circle represents creation, respect, tradition, and harmony. The female is at the center of the sacred circle as she walks in beauty. A woman places great emphasis on her family; her outlook on life and pride in herself reflects this. The mother, aunts, sisters, and grandmothers share in the raising of the child, and family ties continue to be important throughout life.

Sioux mother and child.

The birth of a child is a joyous event, fitting naturally into the life of the family. The child is not excluded from the world of the grown-ups. The grandmother rubs the baby with warm buffalo cow fat when it is born.

An infant spends most of its first year secured in a decorated cradle-board. The cradle is a symbol of protection and greetings to the new life as well as a bed. The buckskin exterior of the Sioux cradle was often decorated elaborately and sometimes covered with porcupine-quill or beaded designs. In the Sioux nation, grandparents of the new baby would make a small beaded hide bag in the shape of a turtle or lizard and place the umbilical cord inside. These animals are respected for their long life and endurance and are believed to bring good luck and protect the child in its growing years. Such bags were attached to the cradleboard or worn around a child's neck.

Mothers would gently pinch a baby's nostrils to stifle any cries, for a crying baby would alert the enemy. Children were quiet and well behaved, learning their relations and the importance of respecting Mother Earth. Children were taught that they are merely passing through life, and only the earth lives forever.

Stories were told by the older generation to the younger, teaching creation, beliefs, values, and morals. Grandmothers assumed most of the responsibility of caring for and instructing the female child. Girls were taught practical skills such as cooking, sewing, tanning hides, decorating with porcupine quills, and sewing buffalo hides together to make tipis. Girls were also taught the spiritual and moral responsibilities of life.

Children took part in ceremonies that pertained to their life. No event in the life of a girl held more significance than the arrival of her first menstrual period. Reaching womanhood was marked with an important ritual sponsored by the parents. It was a proud moment, a time of great celebration. The ceremony was conducted by a medicine man who gave the girl instructions in her adult duties and then fastened an eagle plume to her hair as a symbol

of her new status. The ceremony ended with giveaways and a feast.

Children often imitated their elders in play. They received toys preparing them for their adult roles. Toys were fashioned after objects used by adults, and were made in traditional tribal styles. Little girls played with miniature tipis, dolls that were dressed in tribal clothing, miniature cradleboards, and replicas of household goods.

Throughout adolescence a young woman continued to learn skills she would need as a wife and mother. When she became old enough she was given women's accessories like her mother's awl case, knife sheath, and hide scraper. Her grandmothers kept careful watch over her as she began to mature. Girls married young and looked forward to becoming mothers, welcoming new responsibilities. After bearing her first child, a woman was committed to raising the child and overseeing her household.

A young woman learned to make moccasins well, for someday she would be asked to make a pair for her mother-in-law. The mother-in-law's acceptance of the moccasins would establish a woman as a member of her husband's family.

The grandmother was in charge of making the married couple's tipi, which would remain the wife's property. The woman owned everything in the household except the man's hunting and war implements. It was the woman who put up the tipi and took it down. When it was time to move camp she was responsible for packing the bedding, cooking utensils, food, and clothing, as well as caring for the children.

Warfare was as important in a woman's life as it was in a man's. Women belonged to societies such as the warrior and medicine societies.

Women gathered chokecherries, buffalo berries, wild currants, wild turnips, and wild beans. Foods like these were stored in bladder bags and parfleche boxes when the camp was moved. Women also accompanied their husbands and brothers on buffalo hunts and helped them butcher the buffalo.

The hide was removed and the meat brought back to camp. Women tanned the hides to make a beautiful white buckskin that was used for robes, dresses, shirts, leggings, moccasin tops, tipi covers, pipe bags, and cradles.

Plains Indian clothing displayed the women's artistic skills. Clothing decoration was a female's responsibility. She would decorate with paints, porcupine quillwork, feathers, ribbons, and small tin cones called tinkles. Glass beads from Europe eventually replaced many of the traditional decorative materials. Clothing for rituals and dances tended to be more decorated than that worn for everyday life. Elk's teeth decorations indicated rank, wealth, and power. Cowrie shells on dresses symbolized fertility. Sioux women favored a dress design with a lizard motif to provide protection against female disorders and diseases.

Buckskin dresses were gathered with a beaded belt. Attached to the belt was a knife sheath, an awl, and a strike-a-light pouch containing flint and steel. Porcupine-quilled or beaded moccasins and knee-length leggings were worn. For dress occasions a woman added a long breastplate made from bone. Rawhide was used for moccasin soles, drums, shields, rattles, saddles, stirrups, knife cases, and parfleche boxes.

Certain designs used in decoration belonged to particular families and were handed down from mother to daughter. The elements of life were represented by a variety of symbols: a cross is a star in the heavens, and a triangle is a mountain or tipi. Colors also have special meaning: white symbolizes age; green is growth and development; yellow represents maturity and perfection; and red is sacred and means life. The combination of symbols and colors can tell the story of an object.

At the end of a woman's life she was still useful to her family and tribe. She was respected for her knowledge, wisdom, and power. Today, mothers and grandmothers continue to teach generations' worth of traditions to their children and grandchildren.

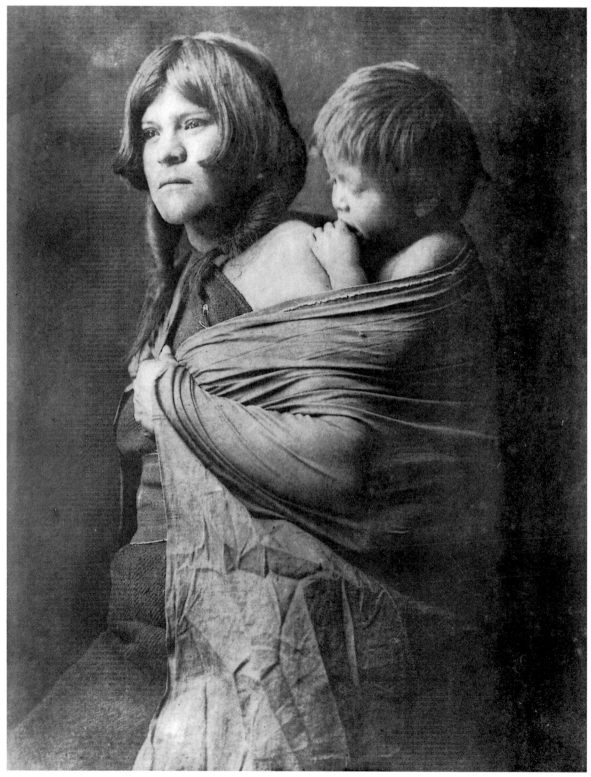

A Hopi mother.

Cheyenne painted buffalo robe

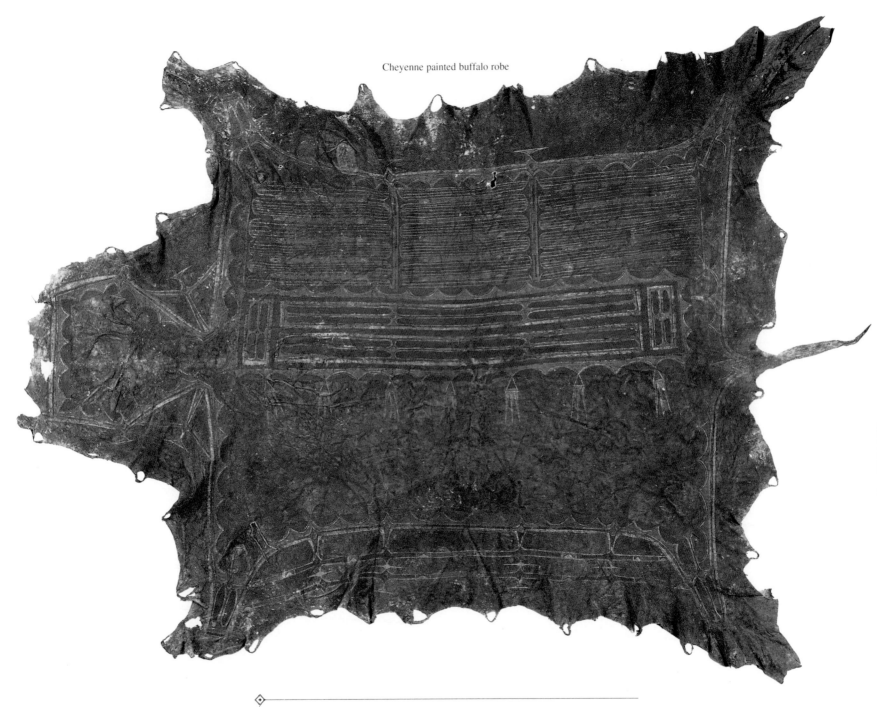

After the buffalo hunt the women butchered and distributed the meat and internal organs to the people. Thinking about full stomachs for her people, a woman painted her buffalo robe using the box-and-border design. The design symbolizes the internal organs of the buffalo.

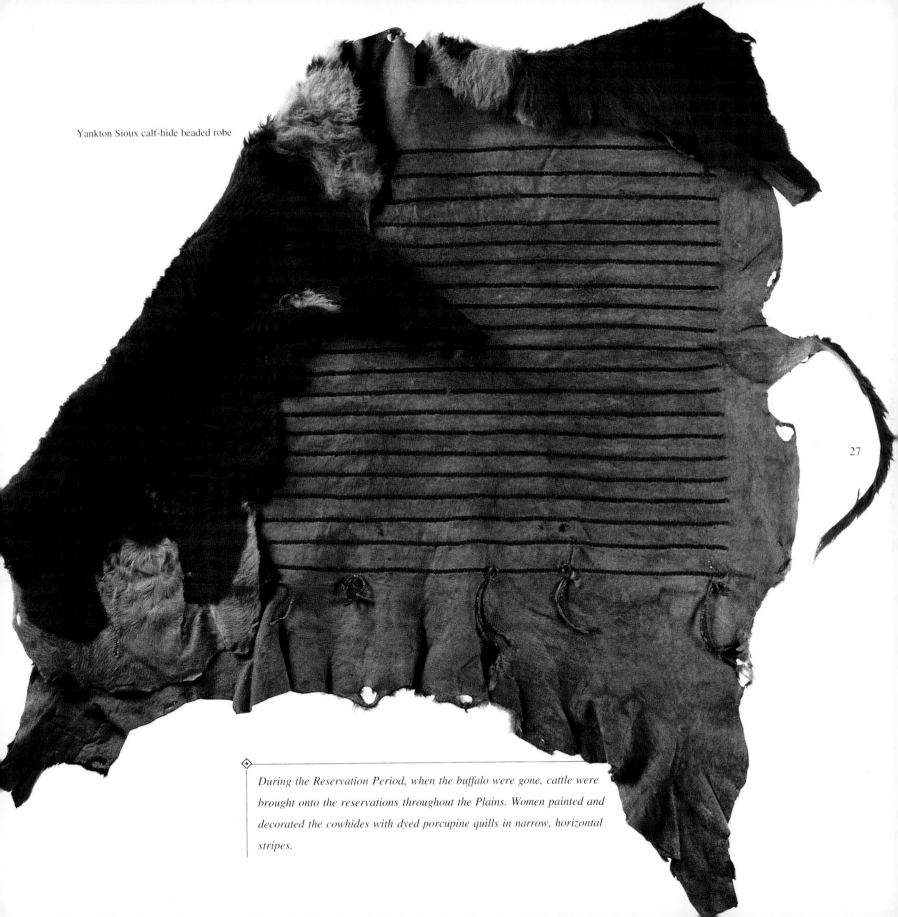

Yankton Sioux calf-hide beaded robe

27

During the Reservation Period, when the buffalo were gone, cattle were brought onto the reservations throughout the Plains. Women painted and decorated the cowhides with dyed porcupine quills in narrow, horizontal stripes.

Indian women from the Eastern Woodlands to the Pacific Northwest wore different kinds of robes, or blankets. The Chippewa, Menomini, and Potawatomi tribes from the Great Lakes region were known for their ribbon applique on navy blue or red trade cloth. These blankets were highly prized by their makers and owners.

28

Potawatomi woman's blanket

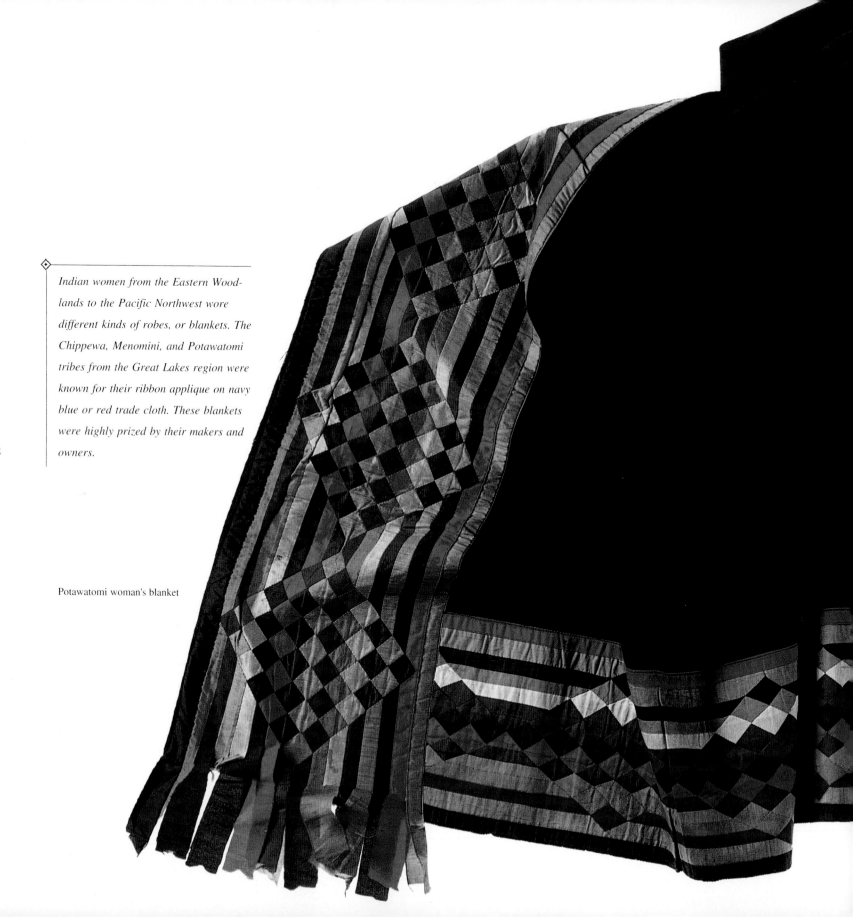

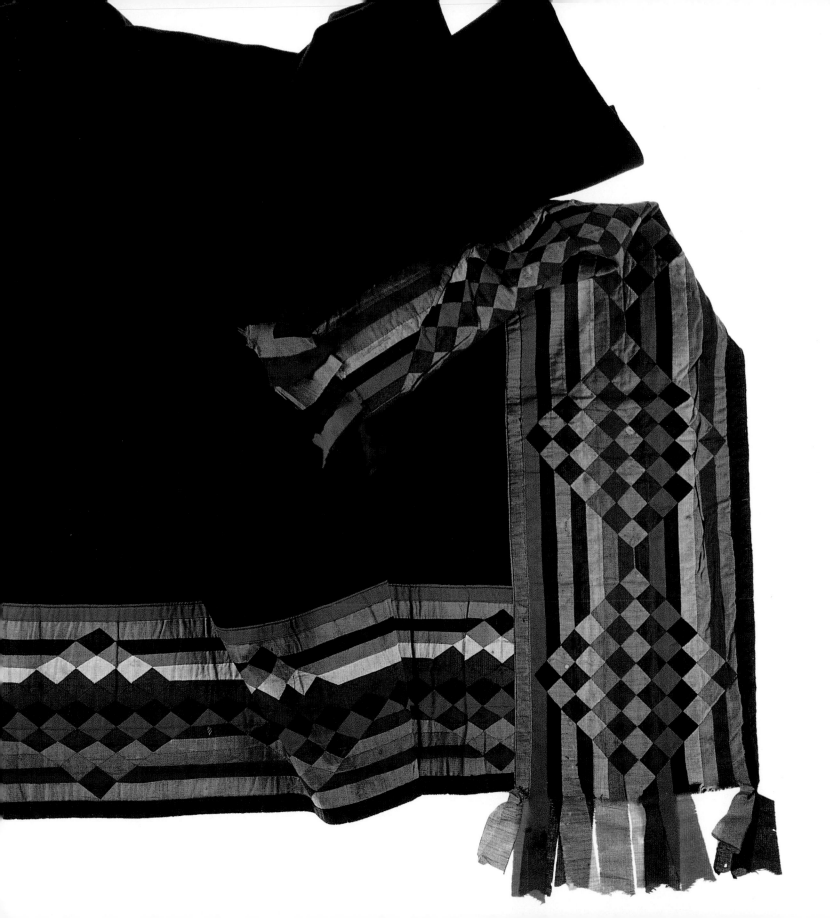

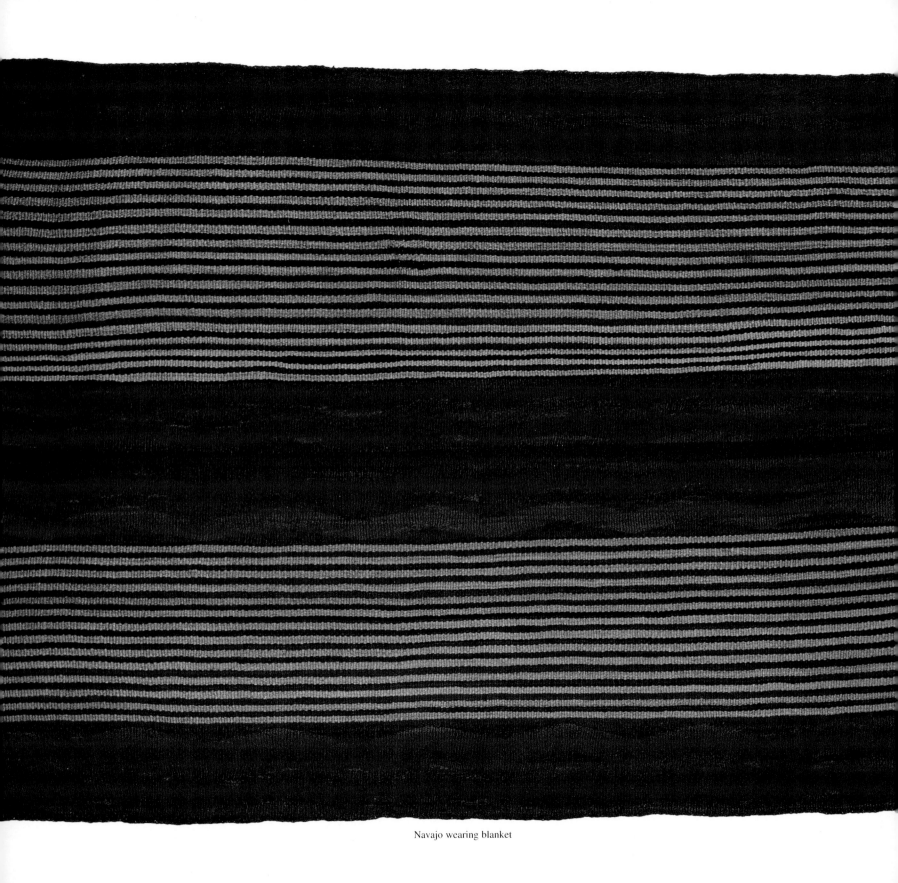

Navajo wearing blanket

Among the Hopi tribe it was traditional that men wove all the mantas (dresses), sashes, and blankets worn by the women. Navajo women were known for their fine weavings. According to their legends it was Spider Woman who taught them how to weave. These wearing blankets were made in the last quarter of the 1800s.

Navajo child's wearing blanket

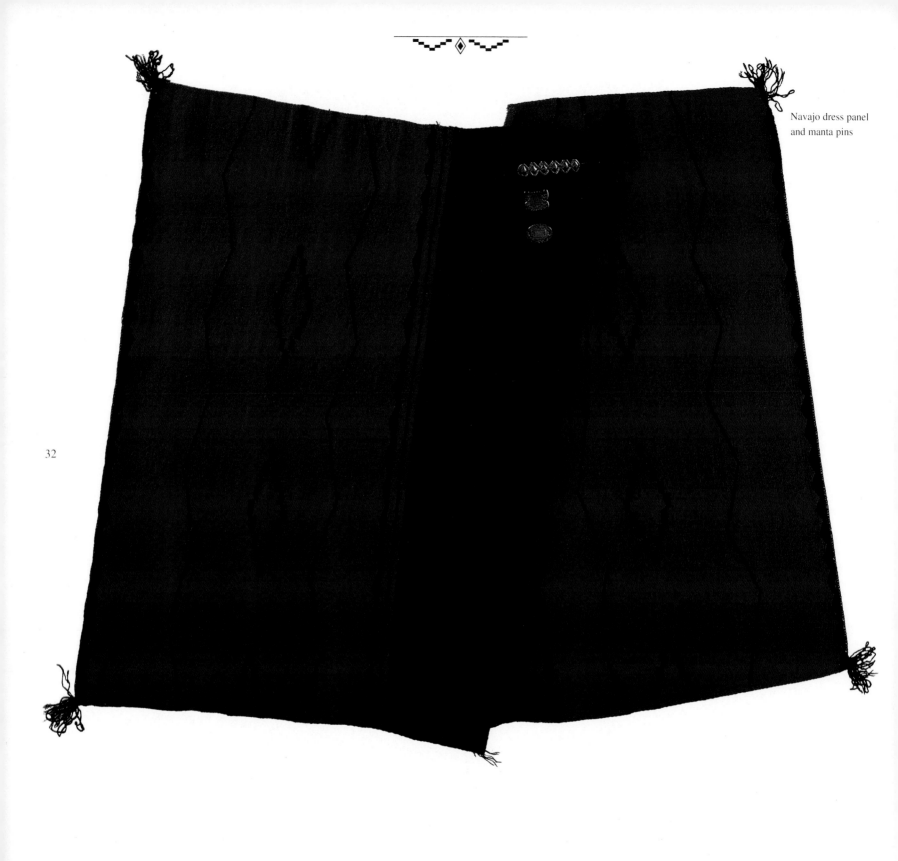

Navajo dress panel
and manta pins

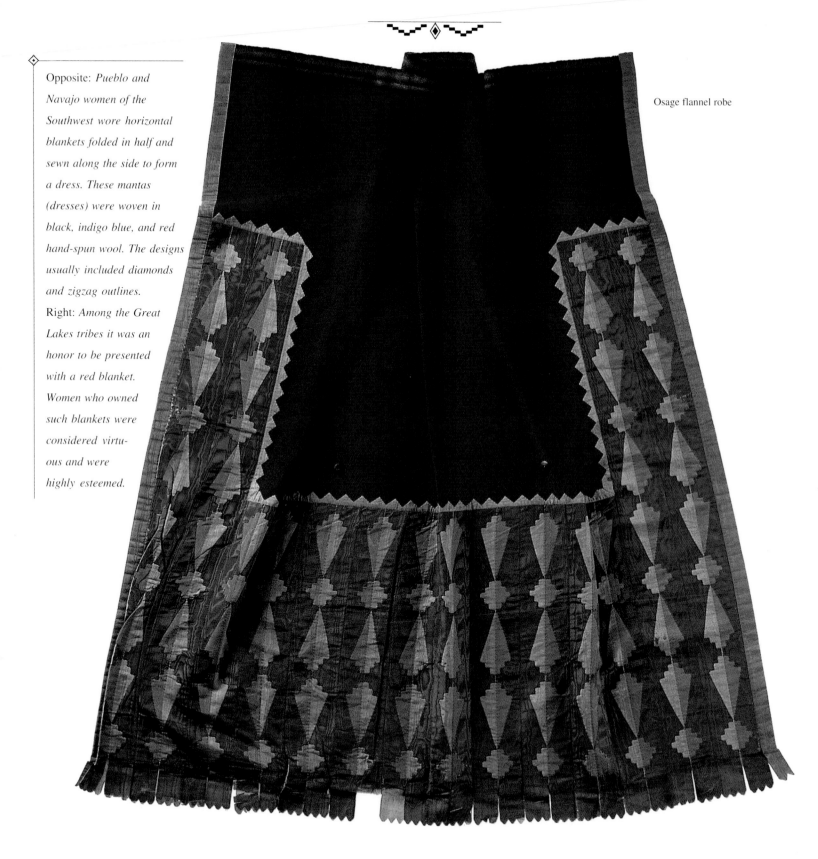

Opposite: *Pueblo and Navajo women of the Southwest wore horizontal blankets folded in half and sewn along the side to form a dress. These mantas (dresses) were woven in black, indigo blue, and red hand-spun wool. The designs usually included diamonds and zigzag outlines.*

Right: *Among the Great Lakes tribes it was an honor to be presented with a red blanket. Women who owned such blankets were considered virtuous and were highly esteemed.*

Osage flannel robe

33

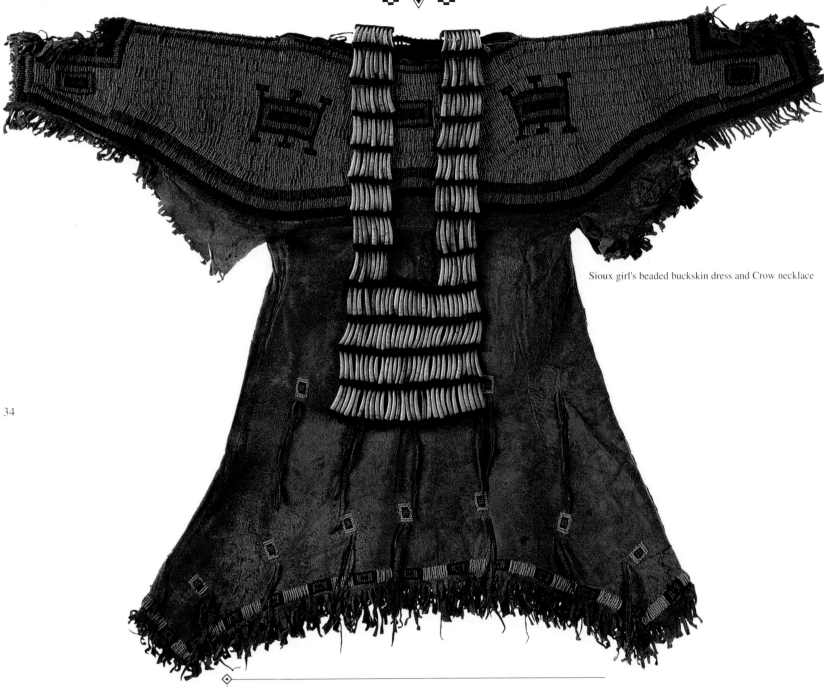

Sioux girl's beaded buckskin dress and Crow necklace

Children were never neglected by their parents or grandparents, but they were brought up under strict discipline. Sometimes a child went to live with her grandmother, and then she gained wisdom and respect at an early age. She not only played, but also learned the different techniques of beadwork and quillwork. During ceremonial and social gatherings, like her mother and grandmother, she wore her beaded buckskin dress.

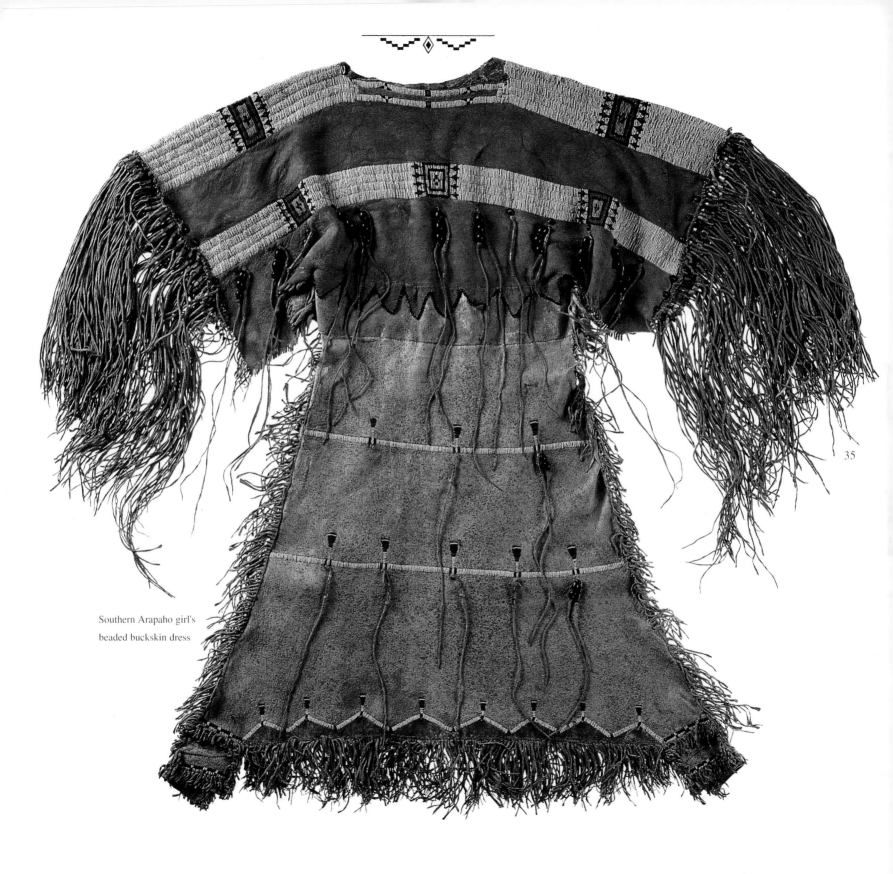

Southern Arapaho girl's
beaded buckskin dress

35

KUMUSH AND HIS DAUGHTER

The earth is my mother.
The sun is my father.
The water is my grandmother.
My home is beyond the setting sun.

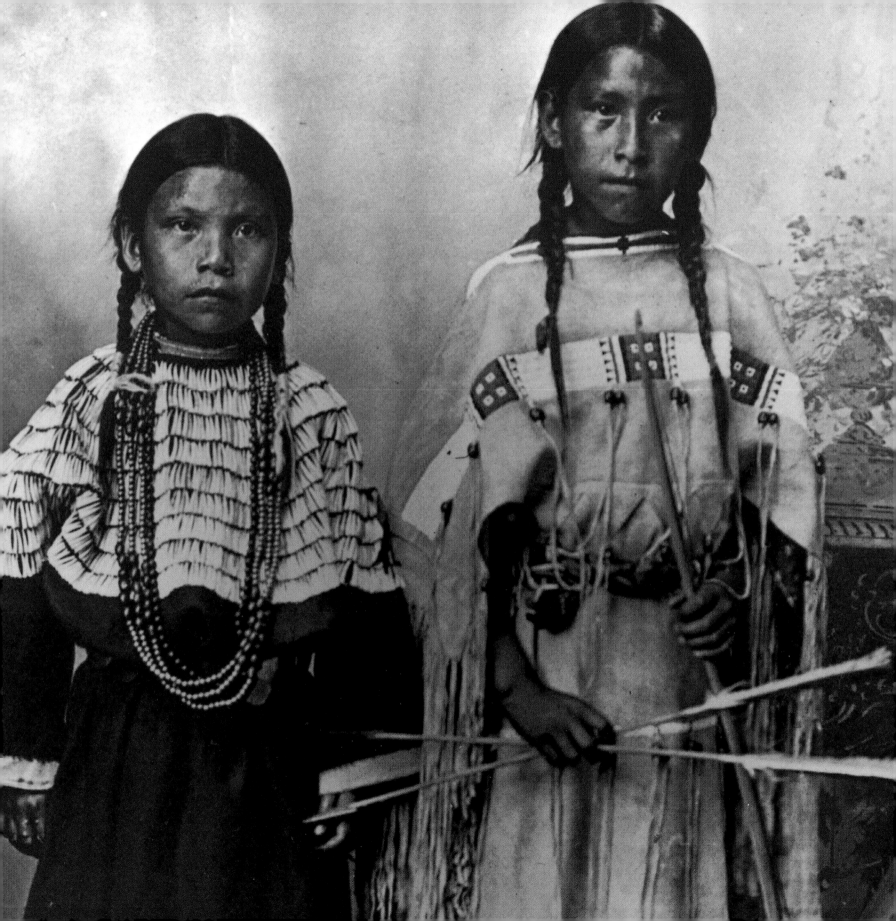

KUMUSH AND HIS DAUGHTER

There is no beginning and no end to the circle of life, for life is endlessly reborn and recreated. This is a legendary story of the Modoc Indian people and their origin. It is a journey to the spirit world that begins with the understanding of birth and death. Untold generations ago when the earth was young, Kumush, the creator, traveled to the spirit land to return with the powers to create many Indian tribes. The spirit in us will someday be called to follow the sacred circle to the spirit world. It will take us to places high and far above, where the powers of the world live and all things unite.

Kumush left Tula Lake and wandered over the earth. He went to the edge of the world and was gone a great many years; then he came back to Nihlaksi, where his sweat-house had been; where Látkakáwas brought the disk; where the body of the beautiful blue man was burned, and where Isis was saved.

Kumush brought his daughter with him from the edge of the world. Where he got her, no one knows. When he came back, Isis and all the people he had made were dead; he and his daughter were alone. The first thing he did was to give the young girl ten dresses, which he made by his word. The finest dress of all was the burial dress; it was made of buckskin, and so covered with bright shells that not a point of the buckskin could be seen.

The first of the ten dresses was for a young girl; the second was the maturity dress, to be worn while dancing the maturity dance; the third was the

*Two Cheyenne girls
in their fine attire.*

dress to be put on after coming from the sweat-house, the day the maturity dance ended; the fourth was to be worn on the fifth day after the dance; the fifth dress was the common, everyday dress; the sixth was to wear when getting wood; the seventh when digging roots; the eighth was to be used when on a journey; the ninth was to wear at a ball game; the tenth was the burial dress.

When they came to Nihlaksi, Kumush's daughter was within a few days of maturity. In the old time, when he was making rules for his people, Kumush had said that at maturity a girl should dance five days and five nights, and while she was dancing an old woman, a good singer, should sing for her. When the five days and nights were over she should bathe in the sweat-house, and then carry wood for five days. If the girl grew sleepy while she was dancing, stopped for a moment, nodded and dreamed, or if she fell asleep while in the sweat-house and dreamed of some one's death, she would die herself.

Kumush was the only one to help his daughter; he sang while she danced. When the dance was over and the girl was in the sweat-house, she fell asleep and dreamed of some one's death. She came out of the sweat-house with her face and hands and body painted with the color of a red root. As she stood by the fire to dry the paint, she said to her father: "While I was in the sweat-house I fell asleep and I dreamed that as soon as I came out some one would die."

"That means your death," said Kumush. "You dreamed of yourself."

Kumush was frightened; he felt lonesome. When his daughter asked for her burial dress he gave her the dress to be worn after coming from the sweat-house, but she wouldn't take it. Then he gave her the dress to be worn five days later, and she refused it. One after another he offered her eight dresses— he could not give her the one she had worn when she was a little girl, for it was too small. He held the tenth dress tight under his arm; he did not want to give it to her, for as soon as she put it on the spirit would leave her body.

"Why don't you give me my dress?" asked she. "You made it before you made the other dresses, and told me what it was for; why don't you give it to me now? You made everything in the world as you wanted it to be."

He gave her the dress, but he clung to it and cried. When she began to put it on he tried to pull it away. She said: "Father, you must not cry. What has happened to me is your will; you made it to be this way. My spirit will leave the body and go west."

At last Kumush let go of the dress, though he knew her spirit would depart as soon as she had it on. He was crying as he said: "I will go with you; I will leave my body here, and go."

"No," said the daughter, "my spirit will go west without touching the ground as it goes. How could you go with me?"

"I know what to do," said Kumush. "I know all things above, below, and in the world of ghosts; whatever is, I know."

She put on the dress, Kumush took her hand, and they started, leaving their bodies behind. Kumush was not dead but his spirit left the body.

As soon as the daughter died, she knew all about the spirit world. When they started she said to her father: "Keep your eyes closed; if you open them you will not be able to follow me, you will have to go back and leave me alone."

The road they were traveling led west to where the sun sets. Along that road were three nice things to eat: goose eggs, wild cherries and crawfish. If a spirit ate of the wild cherries it would be sent back to this world, a spirit without a body, to wander about homeless, eating wild cherries and other kinds of wild fruit. If it ate of the goose eggs, it would wander around the world, digging goose eggs out of the ground, like roots. It would have to carry the eggs in a basket without a bottom, and would always be trying to mend the basket with plaited grass. If it ate of the crawfish it would have to dig crawfish in the same way. A Skoks offered Kumush's daughter these three

41

harmful things, but she did not look at them; she went straight on toward the west, very fast.

After a time Kumush asked: "How far have we gone now?"

"We are almost there," said the girl. "Far away I see beautiful roses. Spirits that have been good in life take one of those roses with the leaves, those that have been bad do not see the roses."

Again Kumush asked: "How far are we now?"

"We are passing the place of roses."

Kumush thought: "She should take one of those roses."

The girl always knew her father's thoughts. As soon as that thought came into his mind, she put back her hand and, without turning, pulled a rose and two leaves. Kumush did not take one. He could not even see them, for he was not dead.

After a time they came to a road so steep that they could slide down it. At the beginning of the descent there was a willow rope. The girl pulled the rope and that minute music and voices were heard. Kumush and his daughter slipped down and came out on a beautiful plain with high walls all around it. It was a great house, and the plain was its floor. That house is the whole underground world, but only spirits know the way to it.

Kumush's daughter was greeted by spirits that were glad to see her, but to Kumush they said "Sonk!" *(raw, not ripe)*, and they felt sorry for him that he was not dead.

Kumush and his daughter went around together, and Kumush asked: "How far is it to any side?"

"It is very far, twice as far as I can see. There is one road down—the road we came—and another up. No one can come in by the way leading up, and no one can go up by the way leading down."

The place was beautiful and full of spirits; there were so many that if every star of the sky, and all the hairs on the head of every man and all the

hairs on all the animals were counted they would not equal in number the spirits in that great house.

When Kumush and his daughter first got there they couldn't see the spirits though they could hear voices, but after sunset, when darkness was in the world above, it was light in that house below.

"Keep your eyes closed," said Kumush's daughter. "If you open them, you will have to leave me and go back."

At sunset Kumush made himself small, smaller than any thing living in the world. His daughter put him in a crack, high up in a corner of the broad house, and made a mist before his eyes.

When it was dark, Wus-Kumush, the keeper of the house, said: "I want a fire!" Right away a big, round, bright fire sprang up in the center, and there was light everywhere in the house. Then spirits came from all sides, and there were so many that no one could have counted them. They made a great circle around Kumush's daughter, who stood by the fire, and then they danced a dance not of this world, and sang a song not of this world. Kumush watched them from the corner of the house. They danced each night, for five nights. All the spirits sang, but only those in the circle danced. As daylight came they disappeared. They went away to their own places, lay down and became dry, disjointed bones.

Wus-Kumush gave Kumush's daughter goose eggs and crawfish. She ate them and became bones. All newcomers became bones, but those who had been tried for five years, and hadn't eaten anything the Skoks gave them, lived in shining settlements outside, in circles around the big house. Kumush's daughter became bones, but her spirit went to her father in the corner.

On the sixth night she moved him to the eastern side of the house. That night he grew tired of staying with the spirits; he wanted to leave the underground world, but he wanted to take some of the spirits with him to people the upper world. "Afterward," said he, "I am going to the place where the sun

rises. I shall travel on the sun's road till I come to where he stops at midday. There I will build a house."

"Some of the spirits are angry with you," said Wus-Kumush. "Because you are not dead they want to kill you; you must be careful."

"They may try as hard as they like," said Kumush; "they can't kill me. They haven't the power. They are my children; they are all from me. If they should kill me it would only be for a little while. I should come to life again."

The spirits, though they were bones then, heard this, and said: "We will crush the old man's heart out, with our elbows."

Kumush left Wus-Kumush and went back to the eastern side of the house. In his corner was a pile of bones. Every bone in the pile rose up and tried to kill him, but they couldn't hit him, for he dodged them. Each day his daughter moved him, but the bones knew where he was, because they could see him. Every night the spirits in the form of living people danced and sang; at daylight they lay down and became disconnected bones.

"I am going away from this place," said Kumush, "I am tired of being here." At daybreak he took his daughter's bones, and went around selecting bones according to their quality, thinking which would do for one tribe and which for another. He filled a basket with them, taking only shin-bones and wrist-bones. He put the basket on his back and started to go up the eastern road, the road out. The path was steep and slippery, and his load was heavy. He slipped and stumbled but kept climbing. When he was half-way up, the bones began to elbow him in the back and neck, struggling to kill him. When near the top the strap slipped from his forehead and the basket fell. The bones became spirits, and, whooping and shouting, fell down into the big house and became bones again.

"I'll not give up," said Kumush; "I'll try again." He went back, filled the basket with bones and started a second time. When he was half-way up he said: "You'll see that I will get to the upper world with you bones!" That

minute he slipped, his cane broke and he fell. Again the bones became spirits and went whooping and shouting back to the big house.

Kumush went down a second time, and filled the basket. He was angry, and he chucked the bones in hard. "You want to stay here," said he, "but when you know my place up there, where the sun is, you'll want to stay there always and never come back to this place. I feel lonesome when I see no people up there; that is why I want to take you there. If I can't get you up now, you will never come where I am."

When he put the basket on his back the third time, he had no cane, so he thought: "I wish I had a good, strong cane." Right away he had it. Then he said: "I wish I could get up with this basketful of bones."

When half-way up the bones again tried to kill him. He struggled and tugged hard. At last he got near the edge of the slope, and with one big lift he threw the basket up on to level ground. "Maklaksûm káko!" *(Indian bones)* said he.

He opened the basket and threw the bones in different directions. As he threw them, he named the tribe and kind of Indians they would be. When he named the Shastas he said: "You will be good fighters." To the Pitt River and the Warm Spring Indians he said: "You will be brave warriors, too." But to the Klamath Indians he said: "You will be like women, easy to frighten." The bones for the Modoc Indians he threw last, and he said to them: "You will eat what I eat, you will keep my place when I am gone, you will be bravest of all. Though you may be few, even if many and many people come against you, you will kill them." And he said to each handful of bones as he threw it: "You must find power to save yourselves, find men to go and ask the mountains for help. Those who go to the mountains must ask to be made wise, or brave, or a doctor. They must swim in the *gauwams* and dream. When you are sure that a doctor has tried to kill some one, or that he won't put his medicine in the path of a spirit and turn it back, you will kill him. If an innocent doctor is

45

killed, you must kill the man who killed him, or he must pay for the dead man."

Then Kumush named the different kinds of food those people should eat—catfish, salmon, deer and rabbit. He named more than two hundred different things, and as he named them they appeared in the rivers and the forests and the flats. He thought, and they were there. He said: "Women shall dig roots, get wood and water, and cook. Men shall hunt and fish and fight. It shall be this way in later times. This is all I will tell you."

When he had finished everything Kumush took his daughter, and went to the edge of the world, to the place where the sun rises. He traveled on the sun's road till he came to the middle of the sky; there he stopped and built his house, and there he lives now.

From *American Indian Design & Decoration*, by LeRoy Appleton; (New York 1971) Dover Publications.

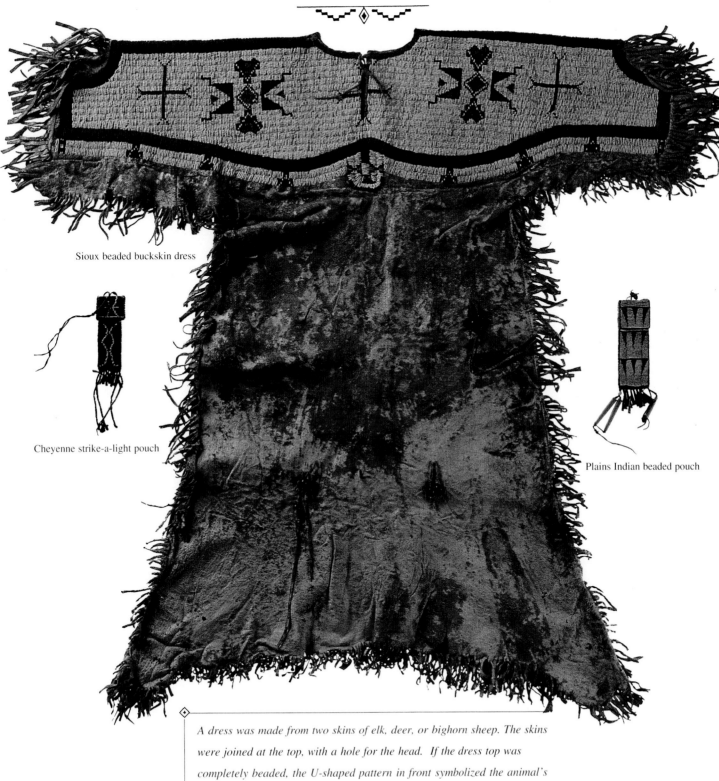

Sioux beaded buckskin dress

Cheyenne strike-a-light pouch

Plains Indian beaded pouch

A dress was made from two skins of elk, deer, or bighorn sheep. The skins were joined at the top, with a hole for the head. If the dress top was completely beaded, the U-shaped pattern in front symbolized the animal's tail, shown in the design above. Sometimes dresses were not completely beaded; in such cases the tail itself was part of the dress.

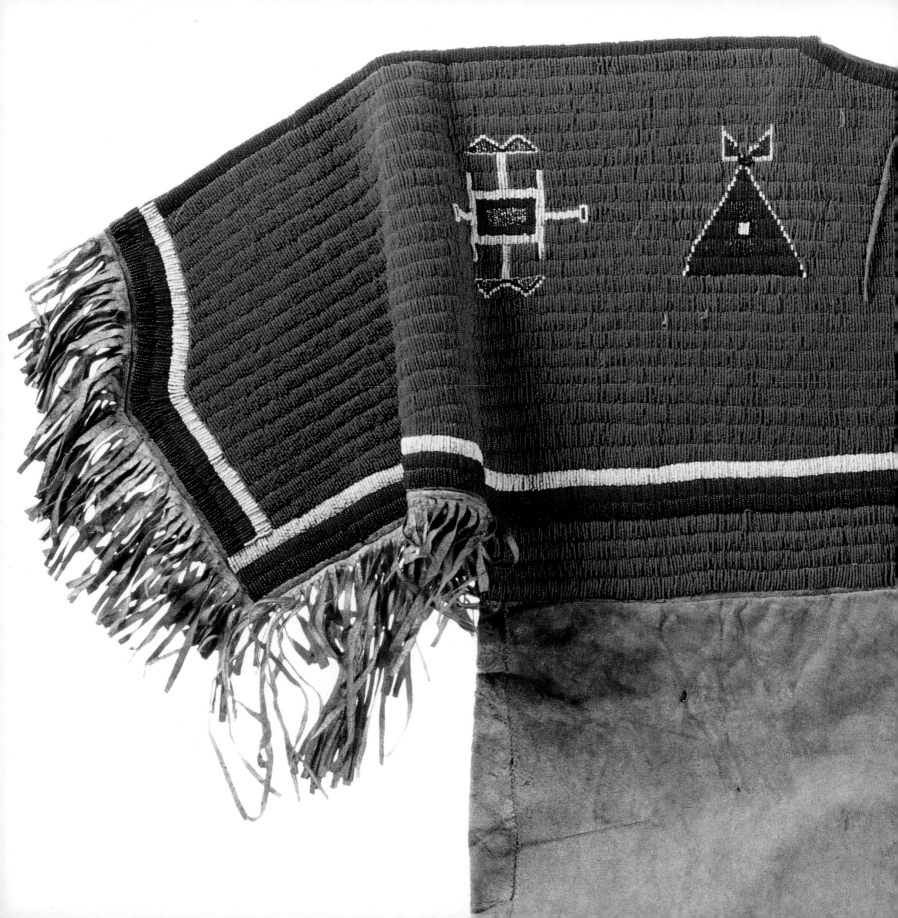

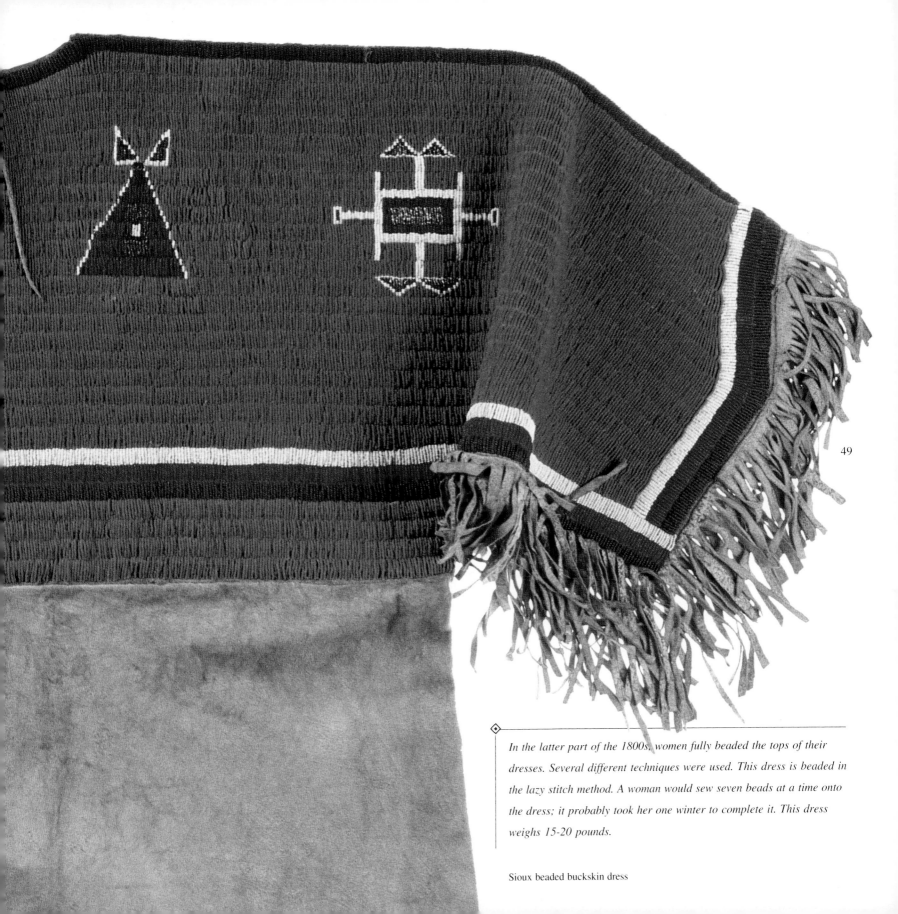

In the latter part of the 1800s, women fully beaded the tops of their dresses. Several different techniques were used. This dress is beaded in the lazy stitch method. A woman would sew seven beads at a time onto the dress; it probably took her one winter to complete it. This dress weighs 15-20 pounds.

Sioux beaded buckskin dress

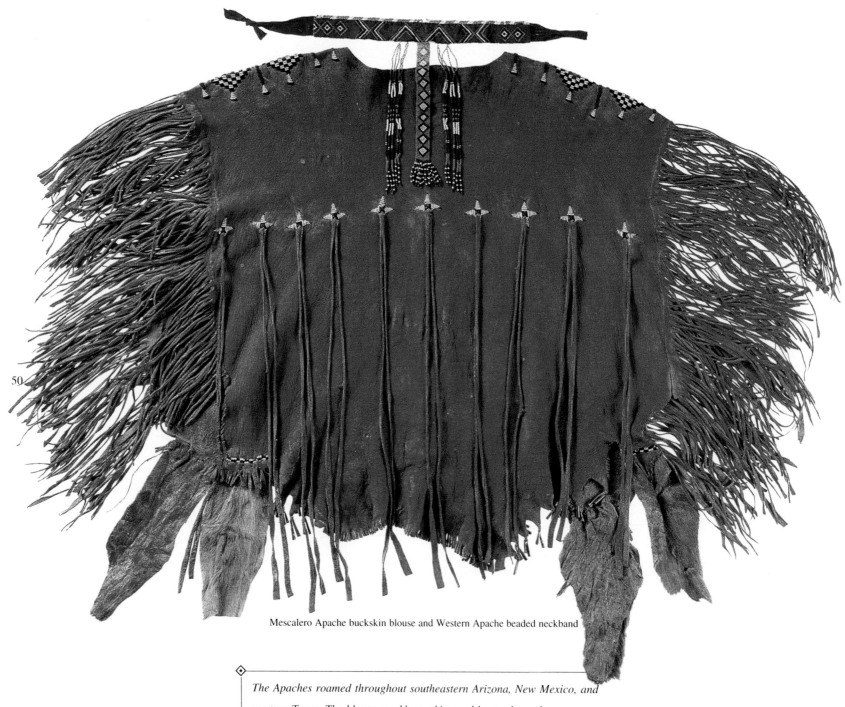

50

Mescalero Apache buckskin blouse and Western Apache beaded neckband

The Apaches roamed throughout southeastern Arizona, New Mexico, and western Texas. The blouse, necklace, skirt, and boots shown here were worn by a girl during her puberty ceremony. Because the Jicarilla Apaches lived near the Utes, their lifestyle showed more Plains influence. Like the Plains Indian women, Apache women beaded their ceremonial clothing.

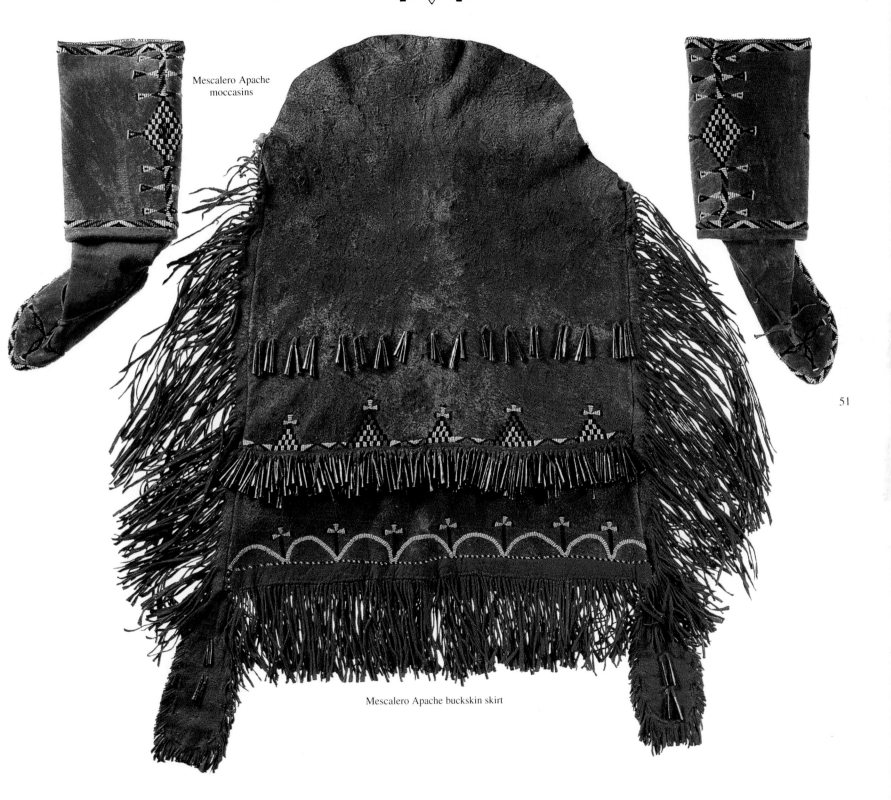

Mescalero Apache
moccasins

51

Mescalero Apache buckskin skirt

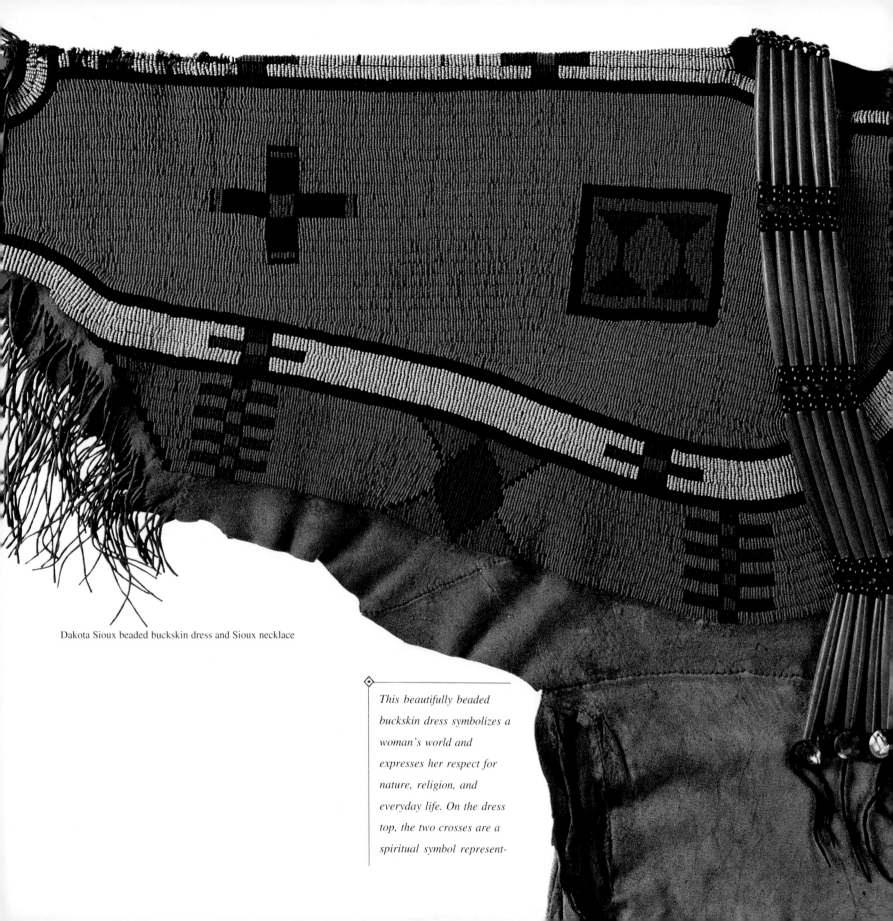

Dakota Sioux beaded buckskin dress and Sioux necklace

This beautifully beaded buckskin dress symbolizes a woman's world and expresses her respect for nature, religion, and everyday life. On the dress top, the two crosses are a spiritual symbol represent-

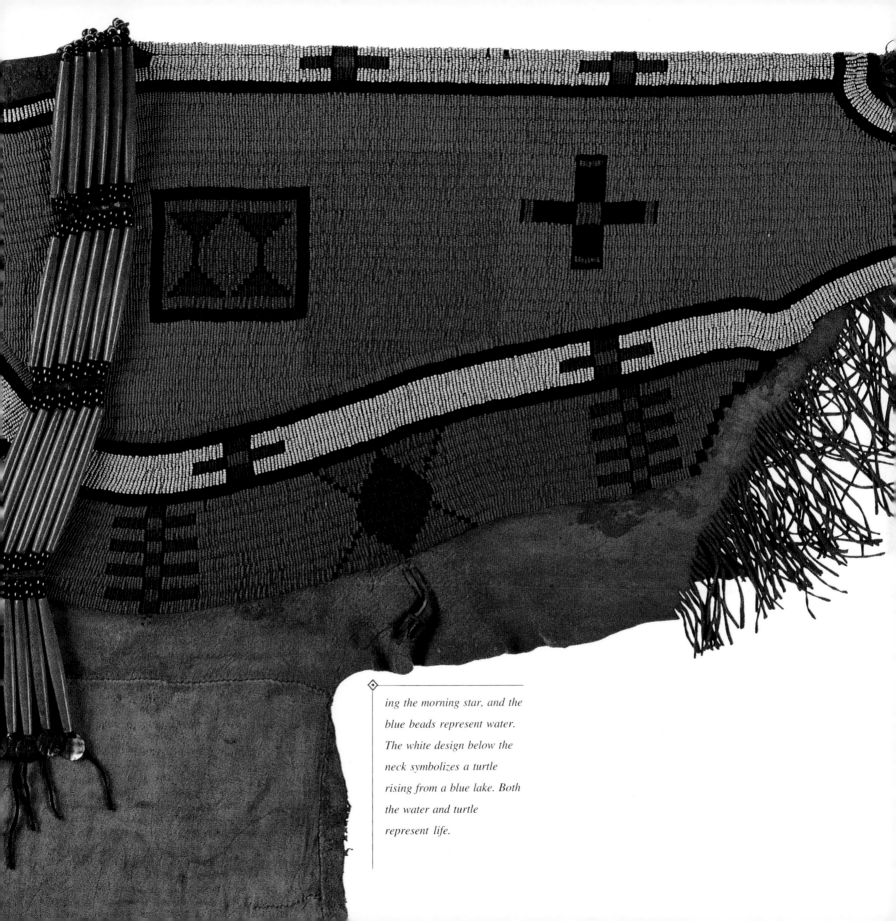

ing the morning star, and the
blue beads represent water.
The white design below the
neck symbolizes a turtle
rising from a blue lake. Both
the water and turtle
represent life.

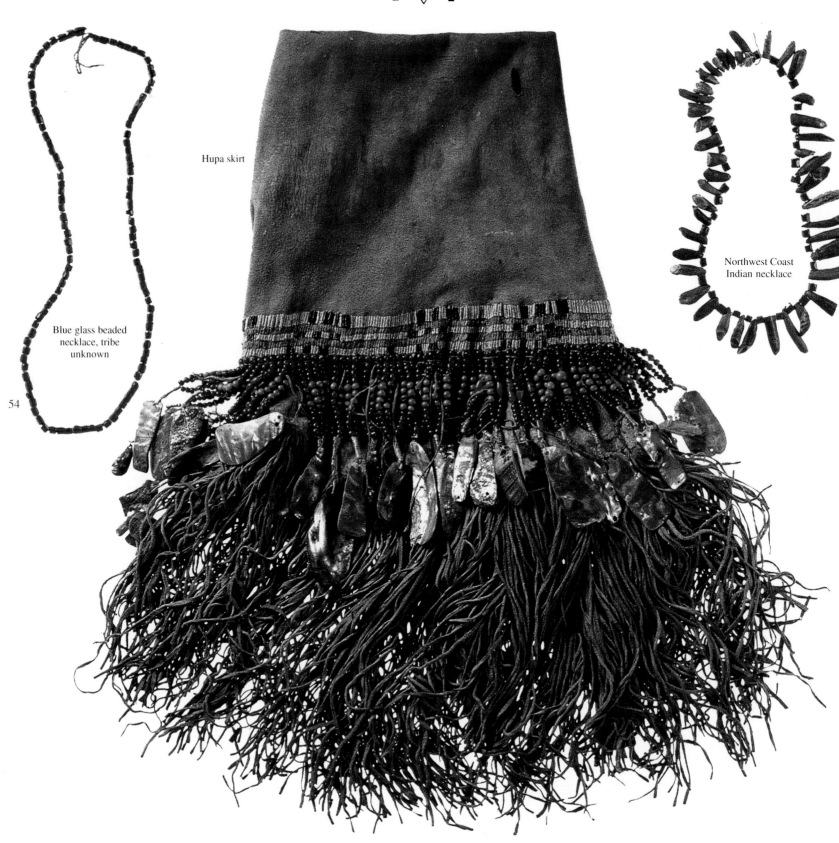

Hupa skirt

Blue glass beaded
necklace, tribe
unknown

Northwest Coast
Indian necklace

54

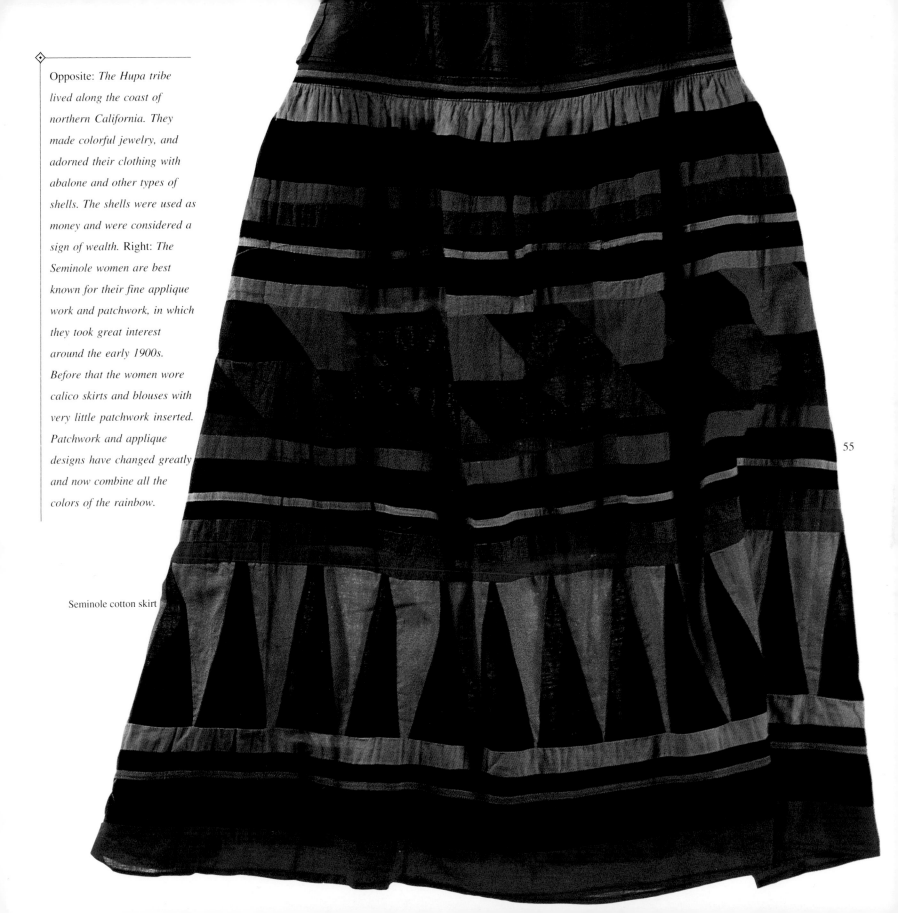

Opposite: *The Hupa tribe lived along the coast of northern California. They made colorful jewelry, and adorned their clothing with abalone and other types of shells. The shells were used as money and were considered a sign of wealth.* Right: *The Seminole women are best known for their fine applique work and patchwork, in which they took great interest around the early 1900s. Before that the women wore calico skirts and blouses with very little patchwork inserted. Patchwork and applique designs have changed greatly and now combine all the colors of the rainbow.*

Seminole cotton skirt

55

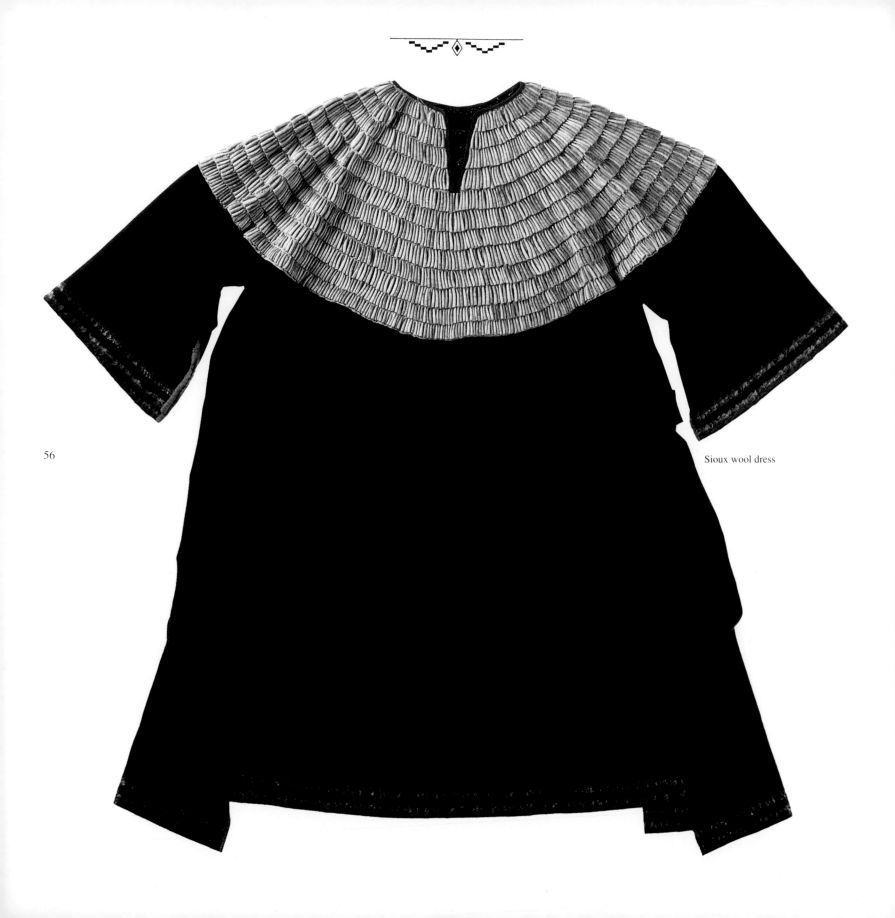

56

Sioux wool dress

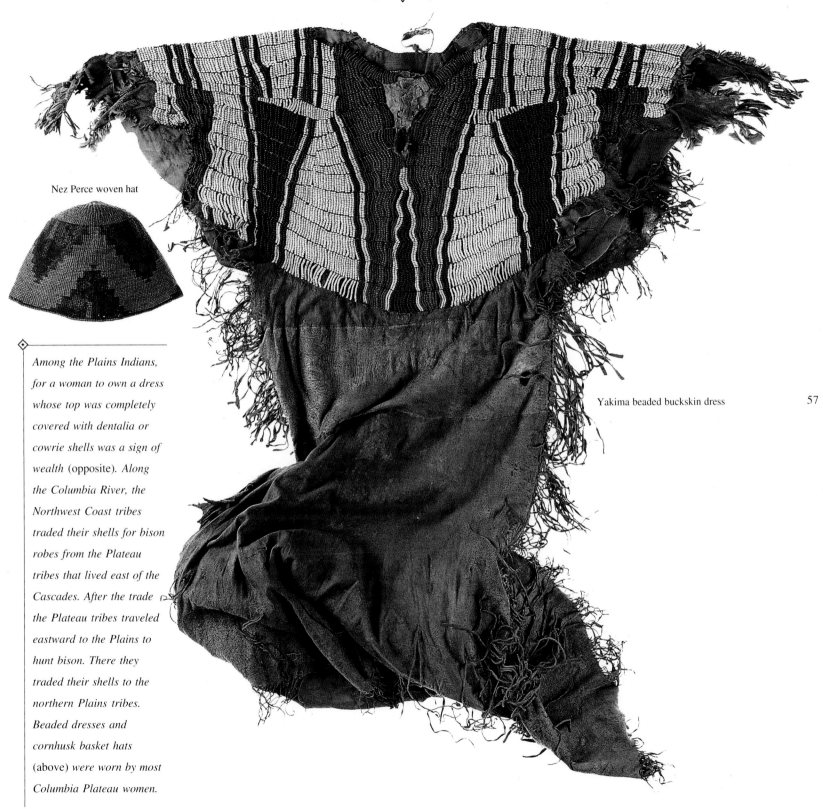

Nez Perce woven hat

Yakima beaded buckskin dress

Among the Plains Indians, for a woman to own a dress whose top was completely covered with dentalia or cowrie shells was a sign of wealth (opposite). Along the Columbia River, the Northwest Coast tribes traded their shells for bison robes from the Plateau tribes that lived east of the Cascades. After the trade the Plateau tribes traveled eastward to the Plains to hunt bison. There they traded their shells to the northern Plains tribes. Beaded dresses and cornhusk basket hats (above) were worn by most Columbia Plateau women.

GRANDMOTHER RECEIVES HER HEALING POWER

*Springtime symbolizes
rebirth and a new beginning.*

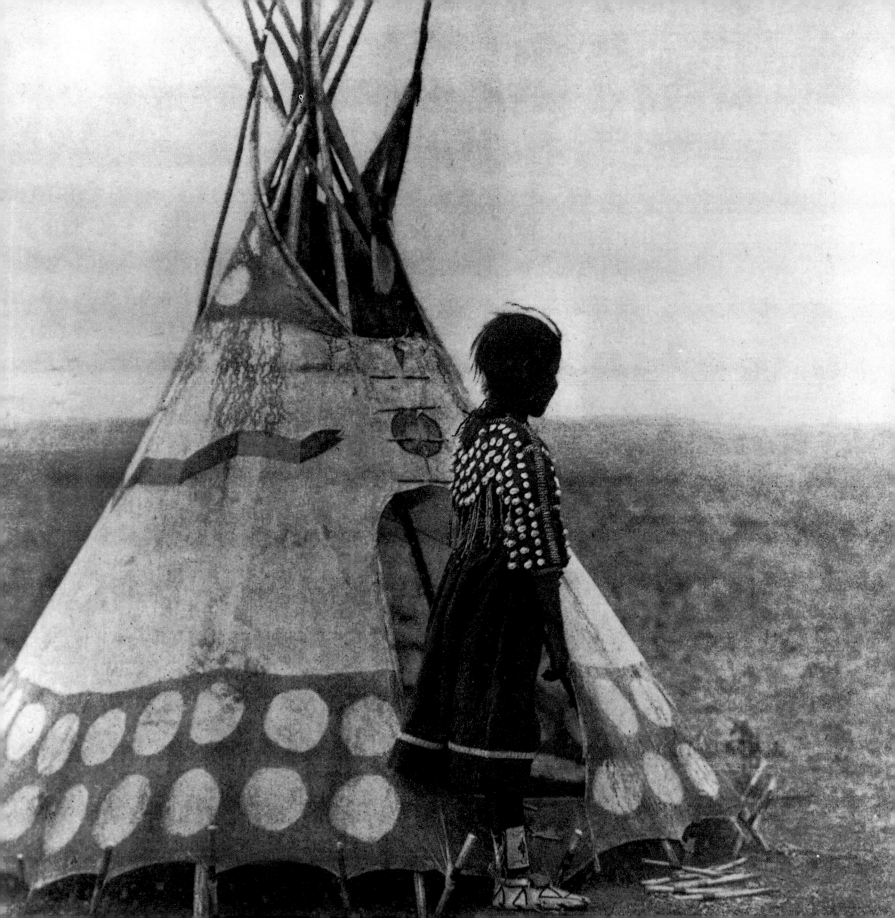

GRANDMOTHER RECEIVES HER HEALING POWER

Indians forever live in a land of mystery, seeing the unseeable and hearing voices that only they can understand. The spiritual world of the Indians includes not only themselves, but also all animals. In many legends, animals take the form of humans and are spoken of as the first people. Animals are holy messengers directing a pathway to power and wisdom; they give visions that determine one's life. The grizzly is regarded with special respect. This story reveals how healing powers were given by a grizzly bear to Mary Sdipp-shin-mah, Fallen from the Sky, a young girl of the Flathead tribe.

When I was a little girl, five or six years old, my mother said to me one day in huckleberry-picking time, "Tomorrow morning we will go up on the high mountain and pick huckleberries."

Next morning she got a horse and we rode double up the mountain. On the way, I told my mother that I saw a spot with many nice, big huckleberries. But she said, "No, we will go farther up the mountain."

Late in the afternoon we were on a high ridge. There we got off the horse and started picking huckleberries. After a while my mother said to me, "You stay here and pick. And you may eat as many berries as you wish. I am going farther up the mountain. I will not be gone long. Nothing will harm you."

I picked some berries, and then I sat down and ate them. The sun set, but Mother did not come back. I called and called for her. Then it got dark, and I was frightened. I cried and cried and cried. Then I walked farther up the

A Piegan Blackfoot child in front of her play tipi.

ridge, crying and crying. After a little rest, I went a little farther. I slept for a while and then I climbed a little higher, still crying.

When the sun came up, I was very tired and sat down on a ridge, facing a gulch thick with forest. I thought I heard something down there, so I stopped crying and listened. I thought I heard the voice of a human being. I listened and listened. Then I saw something coming toward me, coming where the trees were not so thick.

A woman and two children were coming. I felt pretty good, now that I knew people were near me. The three turned into the brush, out of sight, but I could still hear them. The boy and girl were playing and having fun. Soon the three of them came right to me and the mother said, "Well, little girl, what are you doing here? You must be lost. We heard you crying, and so we came up here to give you help."

The mother was a middle-aged woman, well dressed in buckskin. Around her shoulders the buckskin was painted red, and she wore trinkets. The little boy and the little girl were pretty little fellows, clean and also well dressed in buckskin.

"Don't cry anymore, little girl," the mother said. "You come with us."

I jumped up and went with them. The children tried to get me to play with them, but I stayed near the mother.

She told them, "Leave your little sister alone. She is too tired to play."

When we got to the bottom of the gulch, where the bank was not steep, we stopped to get a drink. I stooped over and drank for a long time, for I was very thirsty. When I finished and sat up, I was alone again. The mother and the children were gone. I cried again until I heard the mother's voice say, "Don't cry, little girl. Come up here."

They were sitting on a bank, and I climbed up to them. Then the mother said, "Now we are going to take you back to your people. When you grow up, you will be a good medicine woman. I give you power over all kinds of

sickness. I give you power to heal people. I give you special power to help women give birth to children. But you must never try to do more than I tell you to do. If you do, you will be responsible for suffering and even for death.

"That is all I can tell you now. I have given you your power. These two are your little brother and little sister. I am your mother."

I glanced away and when I looked back, the mother and children were gone. Instead, a grizzly bear sat there beside me, with two little cubs. The mother bear stood up and said, "Now we are ready to take you to your people. Get on my back."

I did. How fast we went, I couldn't say. After a while she stopped and said, "Your people are near here. Walk on a short distance, and you will see them."

And I did.

Now you know why I never accept payment for healing the sick or for helping women in childbirth. My power was not given me for reward of any kind. And I cannot tell anyone how I heal the sick.

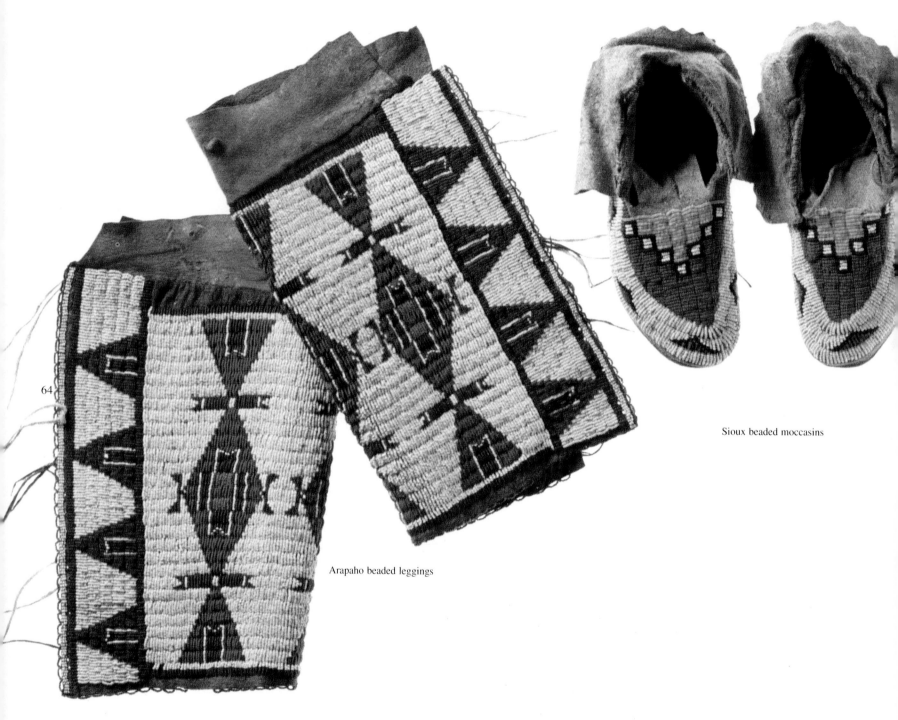

64

Arapaho beaded leggings

Sioux beaded moccasins

Sioux beaded moccasins

Indian women of the Plains wore fully
and partly beaded leggings with hard- or
soft-soled moccasins. Sometimes the
beaded moccasins did not match the
leggings. The Indians used whatever
color beads they had available. White
and blue were favorite background colors
used by most Plains Indian women. The
V-shaped design along the side of each
legging represents the tipi, her home.

Sioux beaded leggings

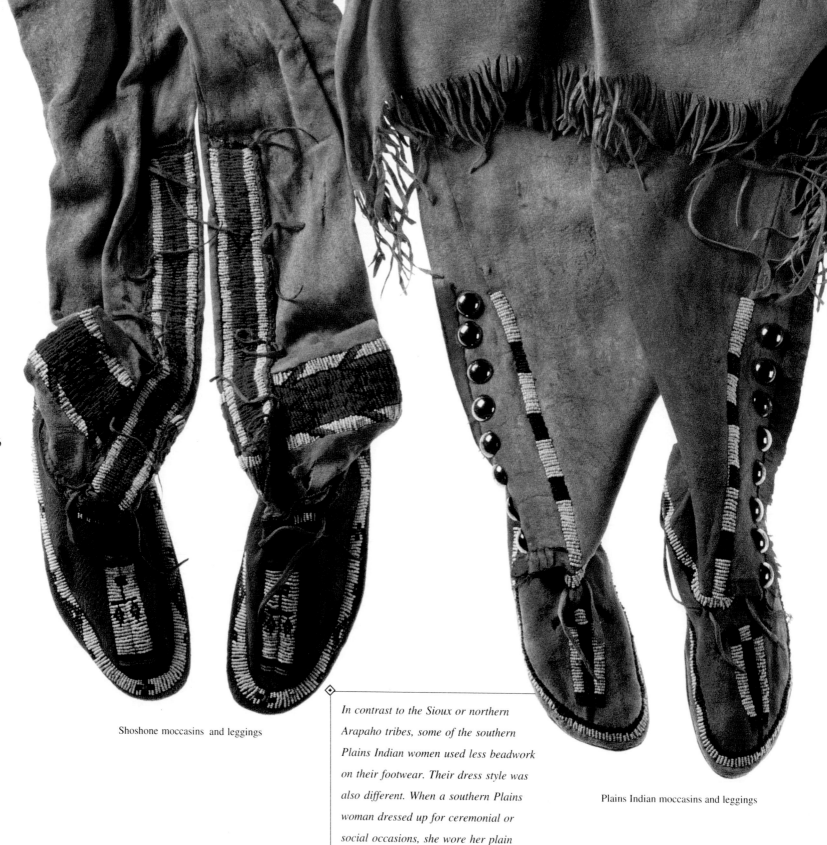

Shoshone moccasins and leggings

In contrast to the Sioux or northern
Arapaho tribes, some of the southern
Plains Indian women used less beadwork
on their footwear. Their dress style was
also different. When a southern Plains
woman dressed up for ceremonial or
social occasions, she wore her plain

Plains Indian moccasins and leggings

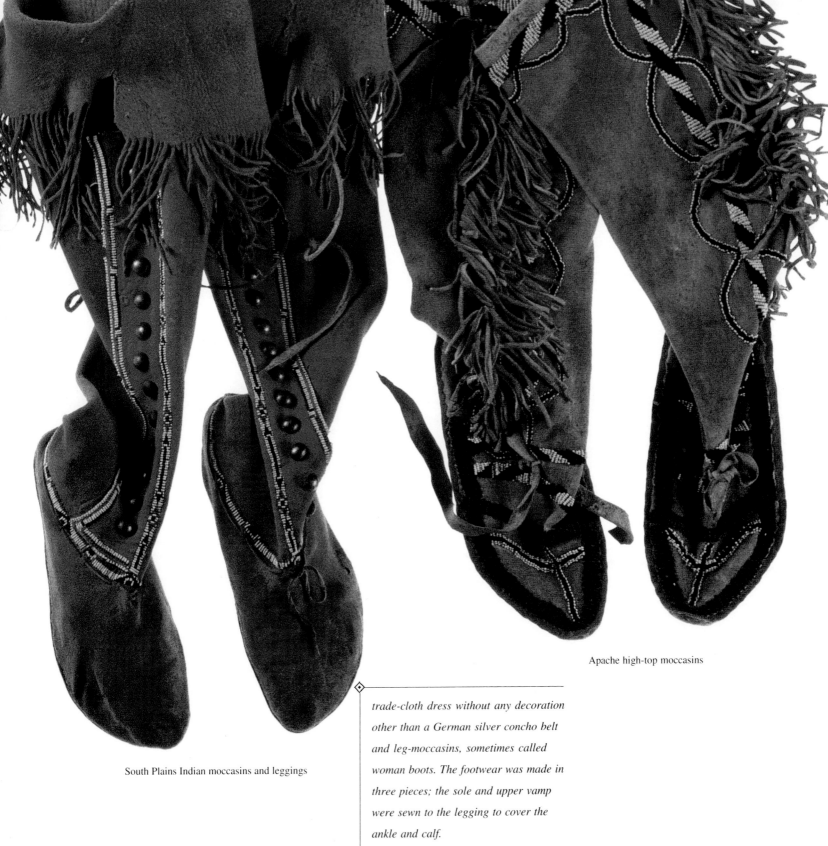

Apache high-top moccasins

South Plains Indian moccasins and leggings

trade-cloth dress without any decoration
other than a German silver concho belt
and leg-moccasins, sometimes called
woman boots. The footwear was made in
three pieces; the sole and upper vamp
were sewn to the legging to cover the
ankle and calf.

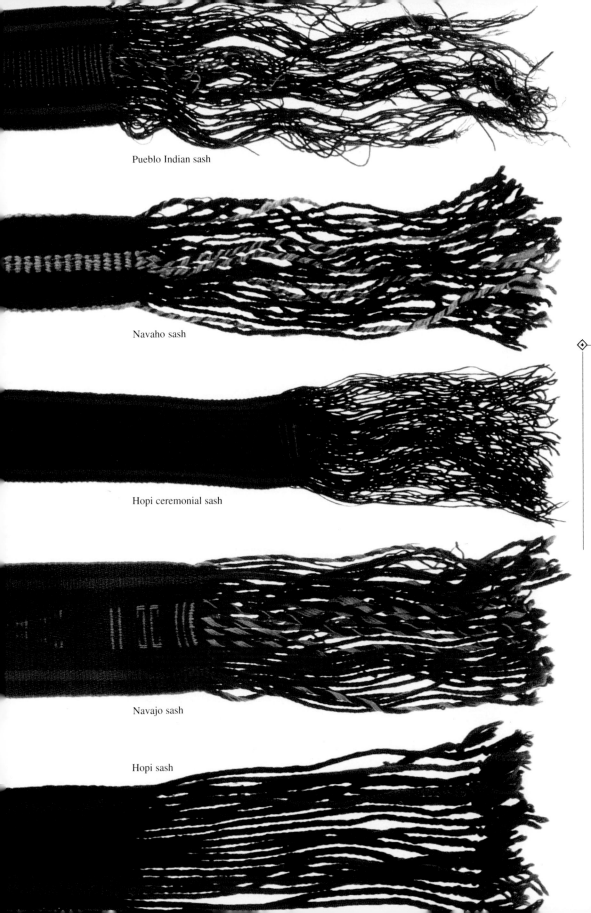

Pueblo Indian sash

Navaho sash

Hopi ceremonial sash

Navajo sash

Hopi sash

*Women of the Pueblo, Navajo, and Hopi
tribes used long, woven sashes during
childbirth. A woman would tie the long
sash to a pole or tree, then pull on it
when she was giving birth. After the baby
was born, she wore the sash around her
waist for a period of time to keep her
stomach firm. Women also wore the
woven sashes during ceremonial dances.*

69

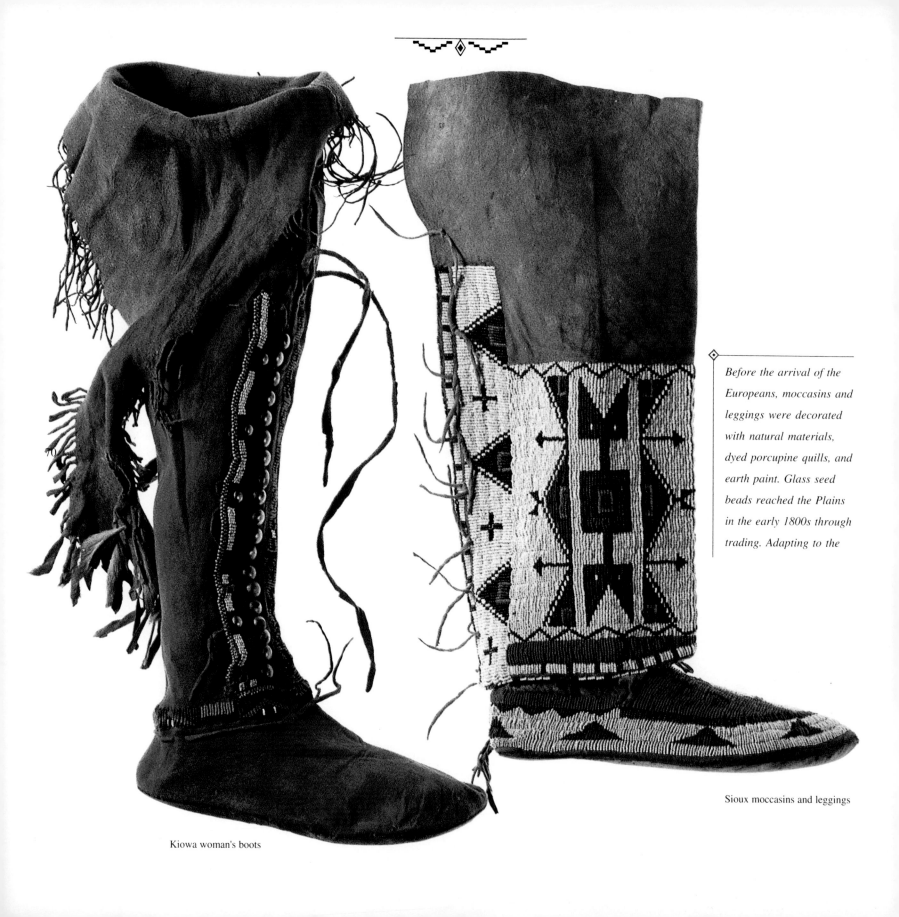

Kiowa woman's boots

Before the arrival of the Europeans, moccasins and leggings were decorated with natural materials, dyed porcupine quills, and earth paint. Glass seed beads reached the Plains in the early 1800s through trading. Adapting to the

Sioux moccasins and leggings

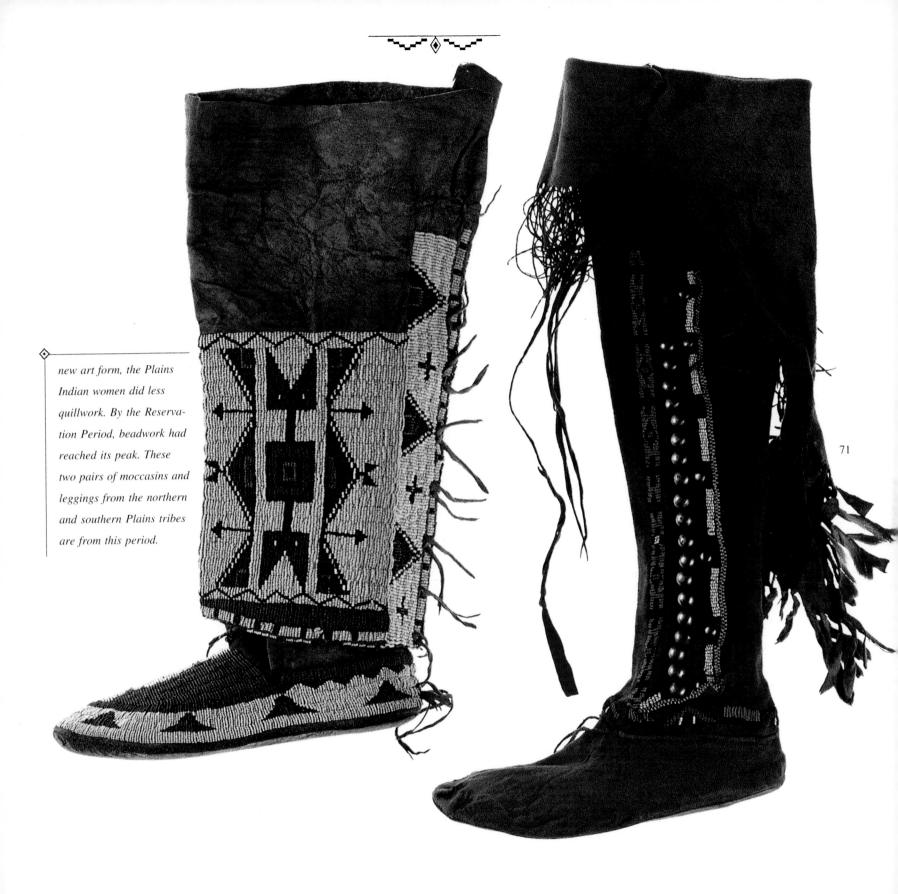

new art form, the Plains Indian women did less quillwork. By the Reservation Period, beadwork had reached its peak. These two pairs of moccasins and leggings from the northern and southern Plains tribes are from this period.

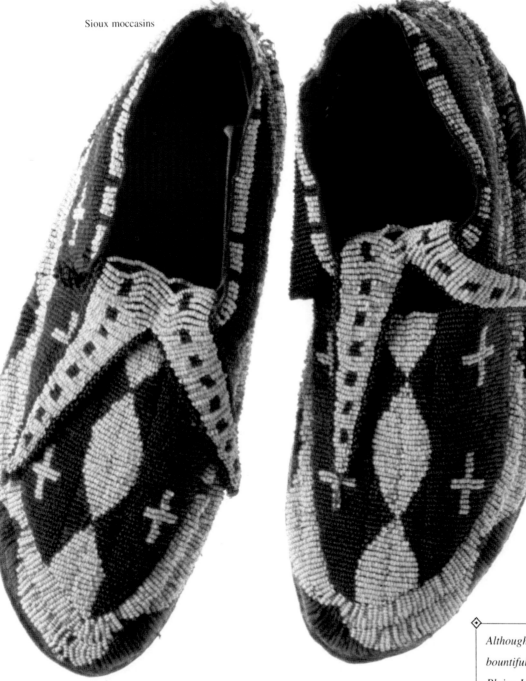

Sioux moccasins

Blackfoot moccasins

72

Although the land was bountiful with buffalo, Plains Indian women reused their old tipis to make clothing. Moccasins were made from smoke flaps of an

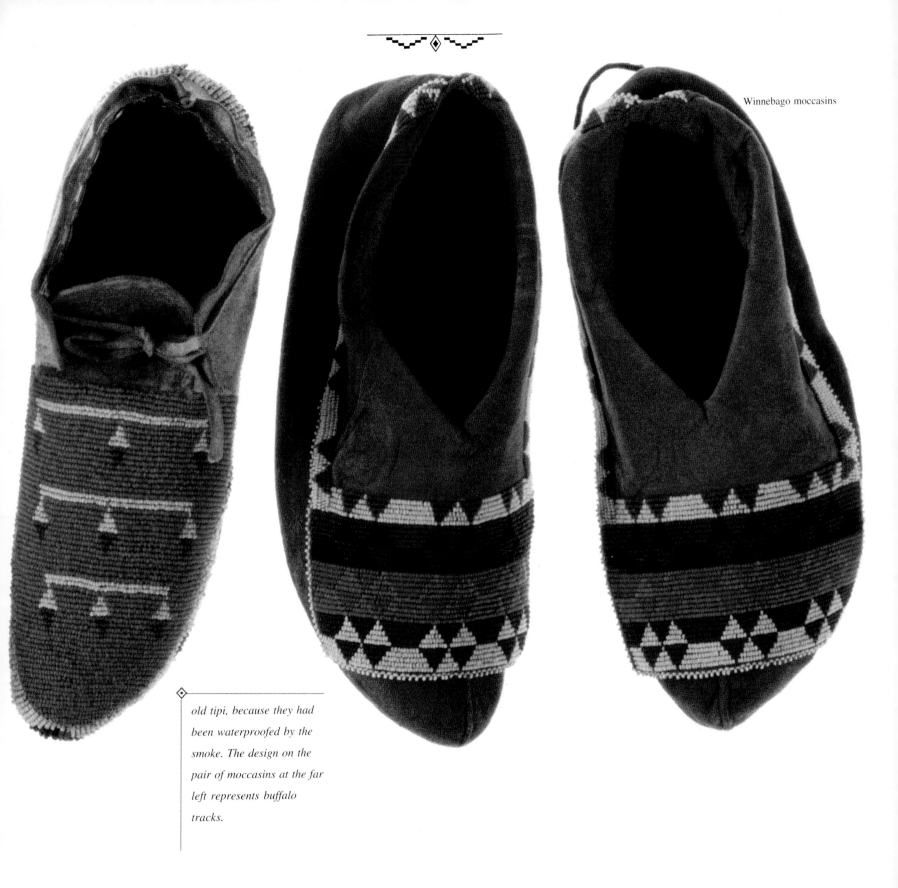

Winnebago moccasins

old tipi, because they had been waterproofed by the smoke. The design on the pair of moccasins at the far left represents buffalo tracks.

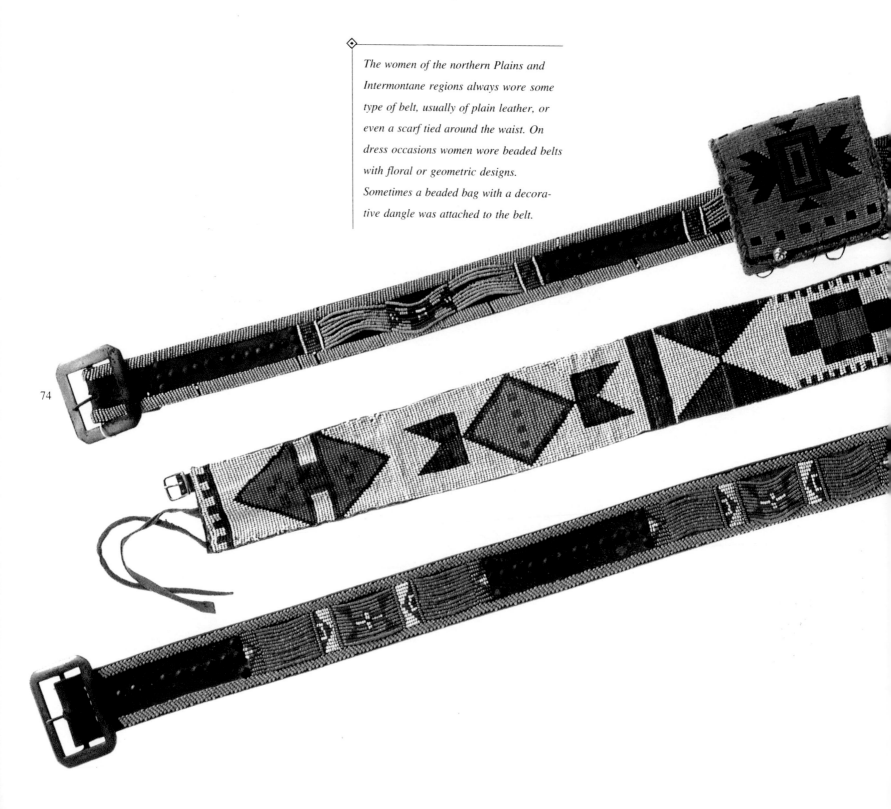

The women of the northern Plains and Intermontane regions always wore some type of belt, usually of plain leather, or even a scarf tied around the waist. On dress occasions women wore beaded belts with floral or geometric designs. Sometimes a beaded bag with a decorative dangle was attached to the belt.

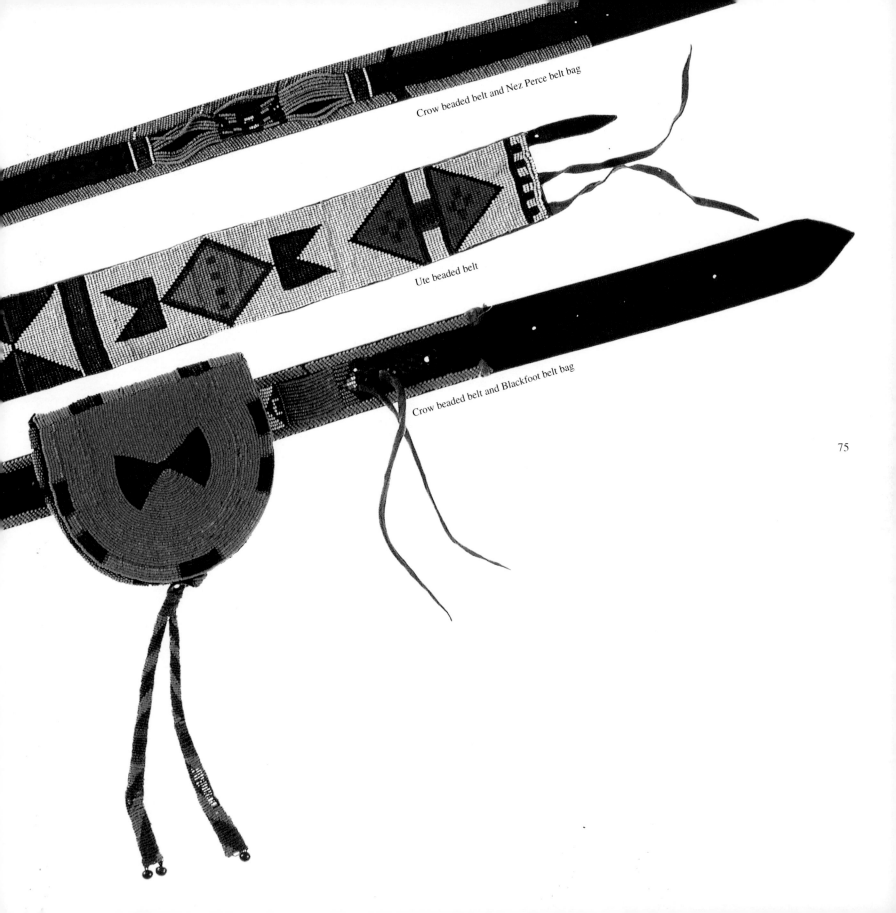

Crow beaded belt and Nez Perce belt bag

Ute beaded belt

Crow beaded belt and Blackfoot belt bag

THE
WOMAN WHO
BROUGHT BACK
THE BUFFALO

The Earth is our Mother.
She gives us life.

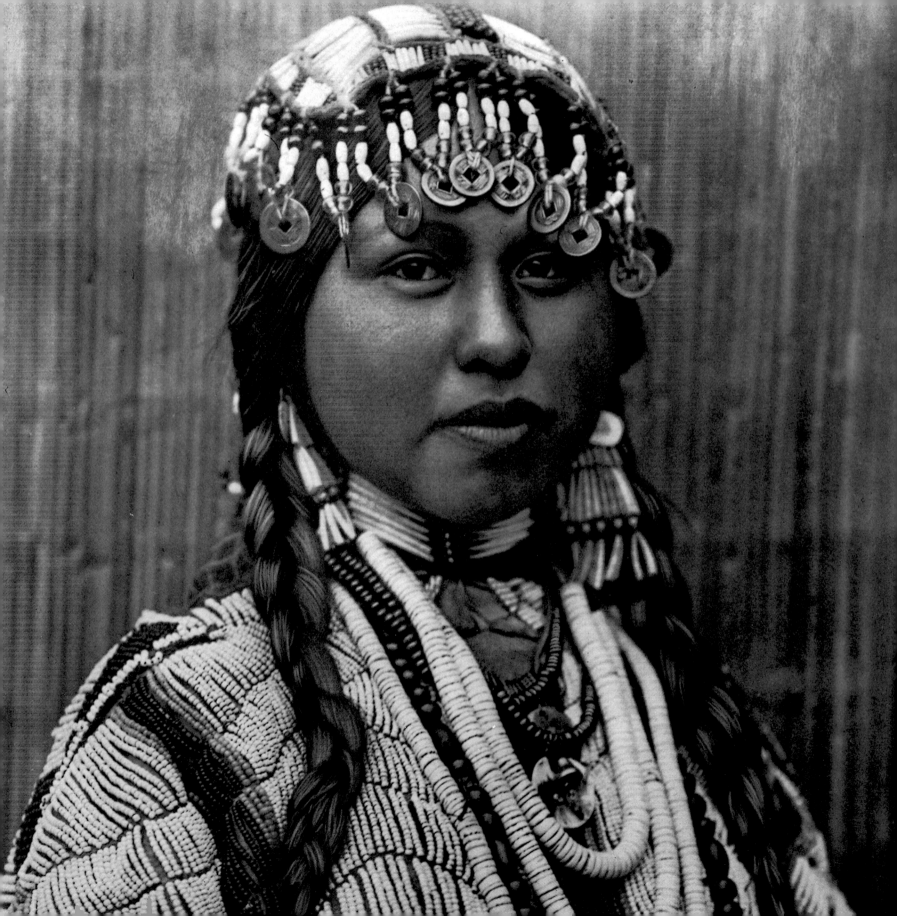

THE WOMAN WHO BROUGHT BACK THE BUFFALO

It is believed that people's lives are lived according to their dreams. Dreams exist within the circle of ourselves. To the Indian, dreams are messages from the spirit world and give to the dreamer a part of the power that moves everything which exists. This story of long ago is about a young Blackfoot woman's dream of a spirit stone that sings to her. Communication with the spirit stone brings the buffalo to her people. The buffalo was one of the most important four-legged animals, a gift of love given to the Indian people by the Great Spirit. It is said that songs made from dreams hold their powers forever.

In the long-ago, before the people had horses, they sometimes starved when they were unable to move their camps fast enough to keep up with the moving buffalo herds. This story takes place during such a famine.

Three sisters were married to the same man. One day they were out gathering firewood. The youngest sister was carrying a large load of wood when her carrying strap broke. Each time she stopped to fix the strap it broke again. Her sisters went back to their lodge while she tried to fix the strap for the fourth time. As she bent over to fix the strap she thought she heard a voice singing. She looked around but could see no one. Yet the voice seemed to be coming from very near by. She became frightened and got up to leave, but the voice called out to her. Then she noticed in the direction of the voice an unusual-looking stone sitting up on the ground near her pile of wood. She went over to take a closer look and saw that the stone was sitting on a little

Wishham bride.

bunch of buffalo hair. The voice began to sing again; it came from the stone: "You woman will you take me? I am powerful! Buffalo is our medicine."

The young woman reached down and picked up the stone. In those days the people had no pockets, and she was not carrying her miscellany pouch. She put the stone beneath her belt, next to her skin, and went home. She did not tell anyone what had happened.

That night she had a dream. The stone came to her and sang its song again. Then it told her: "I have come to you and your people because I pity you. My power is able to communicate with the buffalo and bring them here. I have chosen you to bring me to camp because you are humble and I know your thoughts are good. You must ask your husband to invite all the holy men to your lodge tomorrow night. I will teach you some songs and a ceremony which you must show them. If you do this then I will have my power bring back the buffalo. But you must warn your people: my power is always announced by a strong storm, and when it first arrives it will look like a buffalo, a lone bull. You must tell your people not to harm him. The rest of the herd will follow as soon as he has passed safely through your camp.

During her dream the woman was taught several songs she had never heard before. The Iniskim, or Buffalo Stone, told her that he had many relatives about the prairie, and that all of them were in contact with the same power as he. He told her that any of the people who wished to have good fortune from this power should look for one of his relatives and bring them home and treat them with respect.

When the young woman woke up she wondered what to do about her dream, for she was quite shy of her husband, being the youngest wife. Only the sits-beside wife takes part in the husband's ceremonial functions, never the wife who sleeps closest to the door. When the husband went outside, the young woman told her older sister about the stone and the dream. The sister said: "I will tell our man what you just told me. If your dream comes true,

then you may have my seat next to him. But if not, I will only pity you for what you will have to suffer."

When the husband learned of the matter, he immediately sent out invitations to the camp's holy men. In a short while, they gathered in the home of the young woman and were served a small portion of berries, and broth made from scraps of leather. They were excited when they heard why they were invited, although one or two got up and left. The old people were always skeptical of someone who claimed to have been called upon in a dream and given a power.

With the approval of the holy men who remained, the husband asked his young wife to sit at the head of the tipi and lead the ceremony that had been shown to her. She had a tiny piece of fat, which she mixed with sacred paint in the palms of her hands. While she covered the Buffalo Stone in the sacred paint she sang one of the songs:

Iniskim, he says: Buffalo is my medicine.

Iniskim, he is saying: I am powerful!

The men then knew that it was not an ordinary stone, but a sacred stone. They were anxious to see if it really had any power. The woman then rubbed the Iniskim over her body four times and prayed at great length. Then she sang another song:

This Iniskim, my man, it is Powerful!

During the song she handed the Iniskim to her husband, sitting beside her. He rubbed his body with it and prayed, while his wife continued to sing the sacred songs. The ceremony went on in that way until the Iniskim had gone all the way around the gathered company. By that time most of the men were able to sing one or two of the songs.

Before they left, the woman told them about the warning in the dream. A crier was sent around the camp telling the people to tie down their lodges and prepare for a big storm. They were also told not to harm the single buffalo

81

bull that was to show up in the camp after the storm. Most of the people followed the advice, but a few laughed and said it was only the crazy dream of a woman.

It was long after dark when the weather began to change. Most of the people had gone to sleep. Only the husband, his wife, and some of the holy men stayed up and continued to sing the Iniskim songs. A breeze started to blow, rustling the covers of the tipis. Before long the breeze turned into a wind, and the tipi covers flapped loudly against their poles. The wind continued to get stronger, and suddenly the people were awakened by the cracking sounds of a big cottonwood tree as it was blown down. The unfastened tipis of those who disbelieved the woman were also blown down and their contents hurled away. While the people prayed for safety, they heard loud hoofbeats and heavy breathing in the darkened camp. It was the lone bull wandering through the camp. No one dared to harm him.

In the morning the storm stopped and there was a large herd of buffalo grazing beside the camp. The people were able to bring down as many as they needed, for the animals just wandered around without alarm. The people cried with happiness for having real food again. They were anxious to replace their worn-out bedding and robes, and to fix the holes in their tipis and moccasins. Everyone paid their respects to the young wife, who now occupied the place next to her husband at the head of the tipi. Everyone brought a tiny offering of buffalo meat or fat and placed it before the sacred Iniskim, which was sitting on a little pile of fur inside of the cleared-earth altar at the back of the tipi.

Ever since then my people have had the power of the Iniskims. Every family had at least one of them, and they were contained inside many medicine bundles as well. Boys and girls were sometimes given an Iniskim fastened to the end of a necklace, which they could wear as a good-luck charm.

82

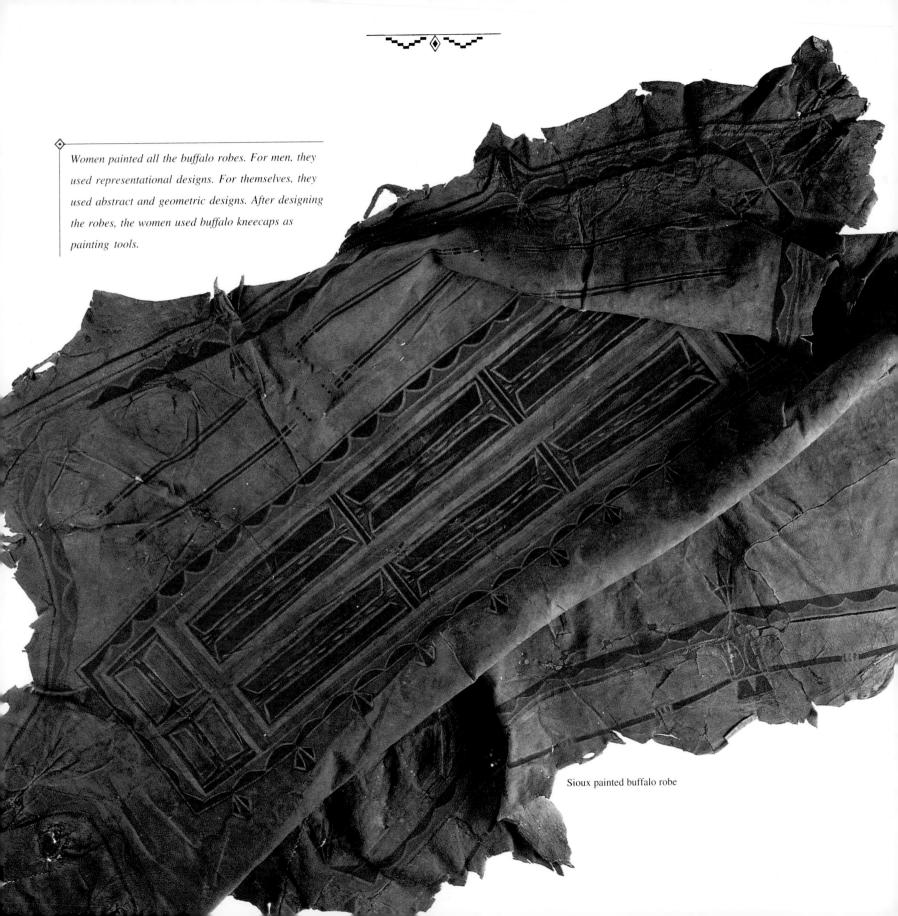

Women painted all the buffalo robes. For men, they used representational designs. For themselves, they used abstract and geometric designs. After designing the robes, the women used buffalo kneecaps as painting tools.

Sioux painted buffalo robe

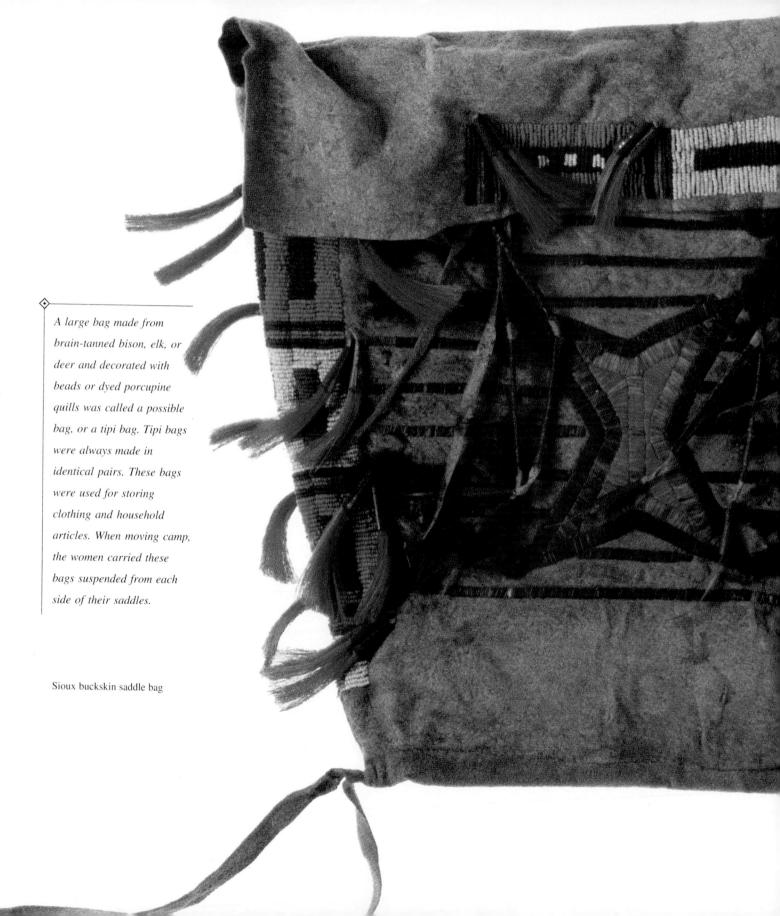

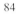

A large bag made from brain-tanned bison, elk, or deer and decorated with beads or dyed porcupine quills was called a possible bag, or a tipi bag. Tipi bags were always made in identical pairs. These bags were used for storing clothing and household articles. When moving camp, the women carried these bags suspended from each side of their saddles.

84

Sioux buckskin saddle bag

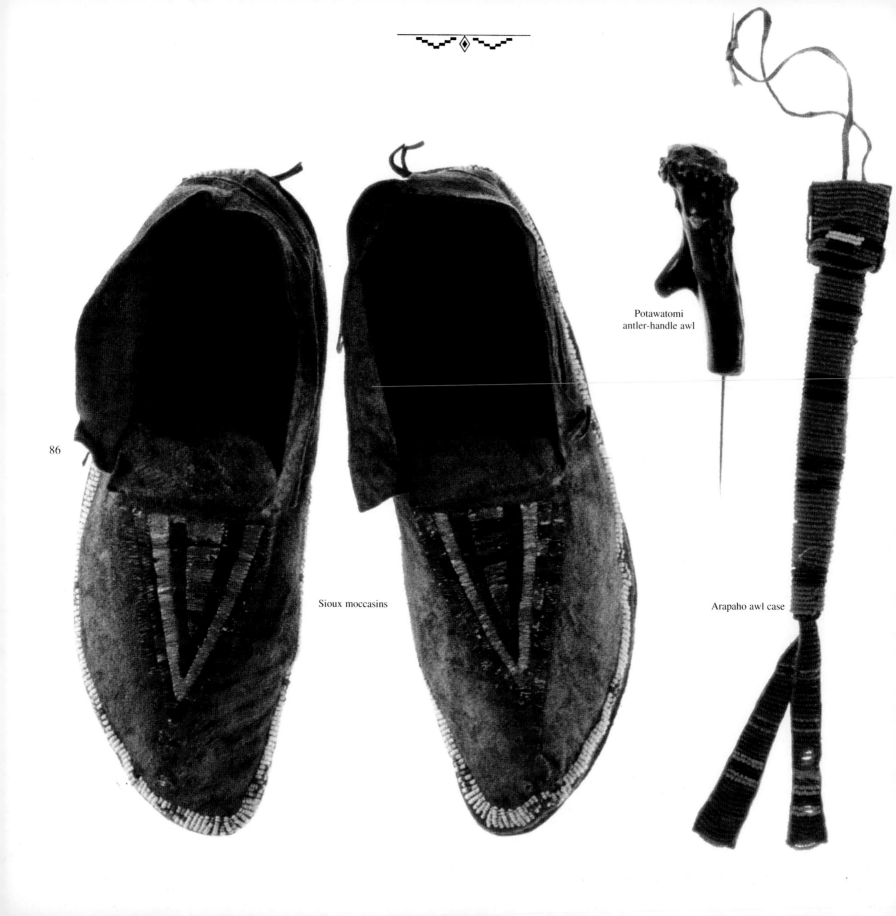

86

Sioux moccasins

Potawatomi
antler-handle awl

Arapaho awl case

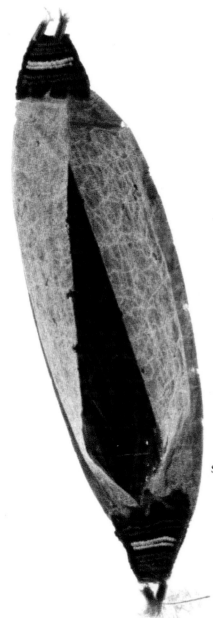

Women kept quills in a buffalo bladder pouch. Among the Sioux, Cheyenne, and Arapaho tribes there existed a women's sewing society, whose members used distinctive designs and patterns. This society is no longer in existence; it has disappeared along with the women who once belonged to it.

Sioux buffalo-bladder quill case

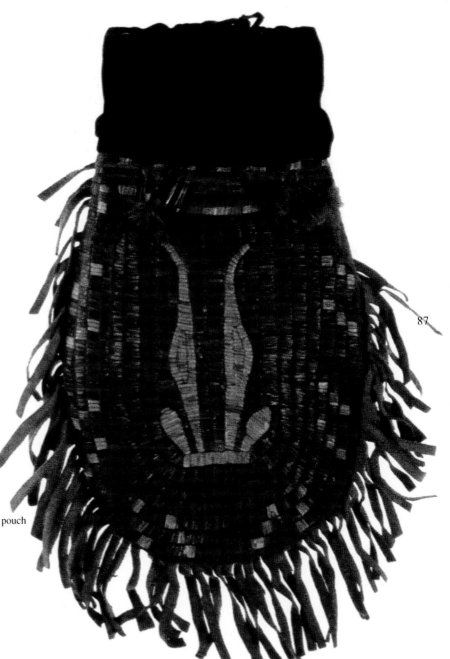

Sioux quilled pouch

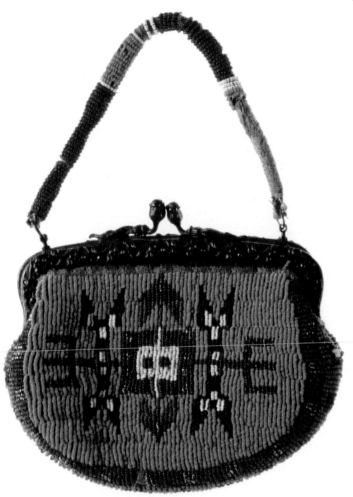

Sioux beaded purse

An unlimited variety of bags and pouches were used by North American Indian women for storing personal and daily necessities. During the latter part of the 1800s, Apache women made drawstring

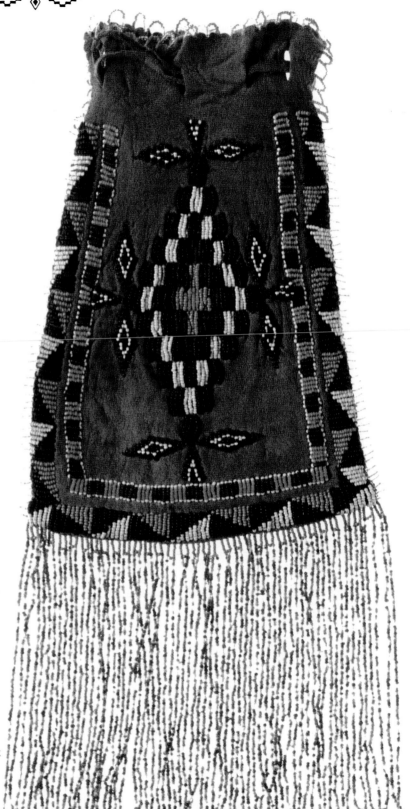

Sioux beaded bag

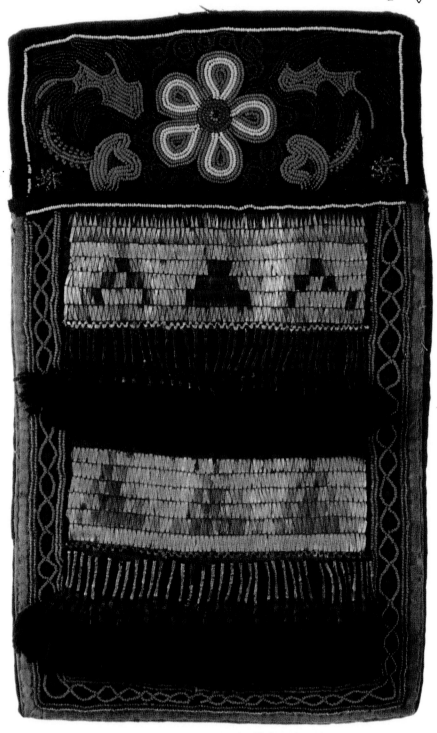

Chippewa-Cree beaded and quilled pouch

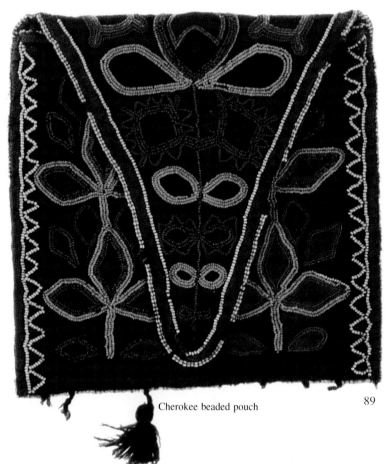

Cherokee beaded pouch

pouches with beaded fringes, copying a pattern from commercially manufactured purses. During the same period Sioux women applied beadwork to manufactured purses with metal fittings.

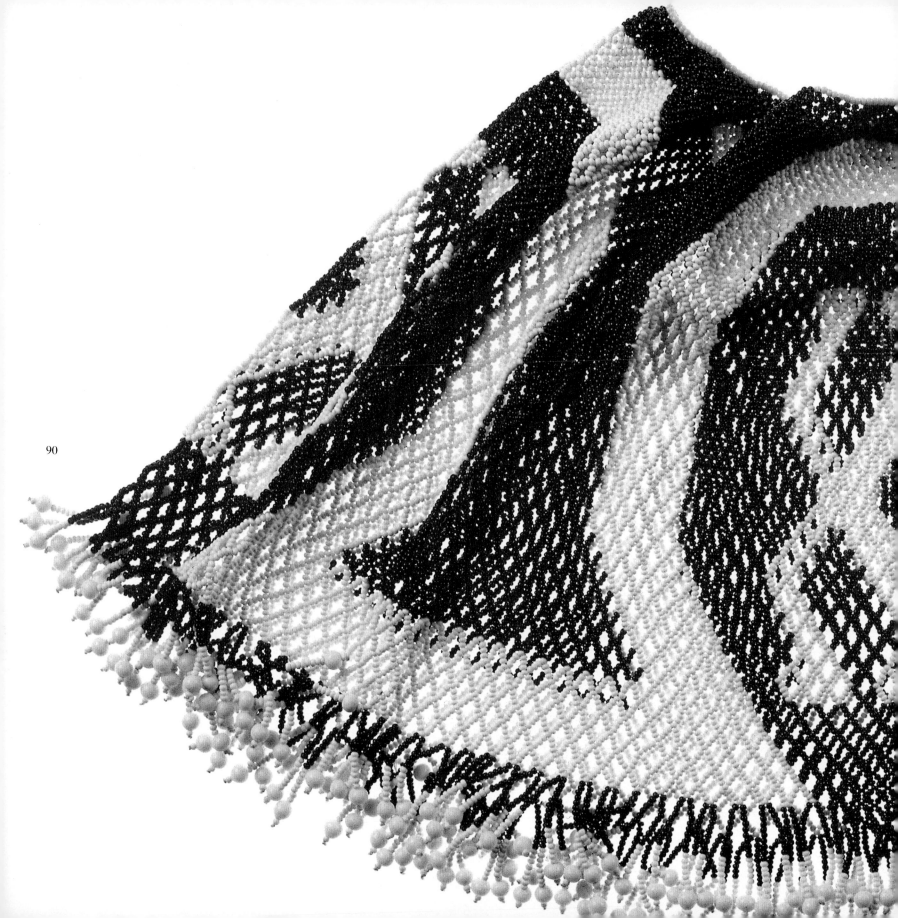

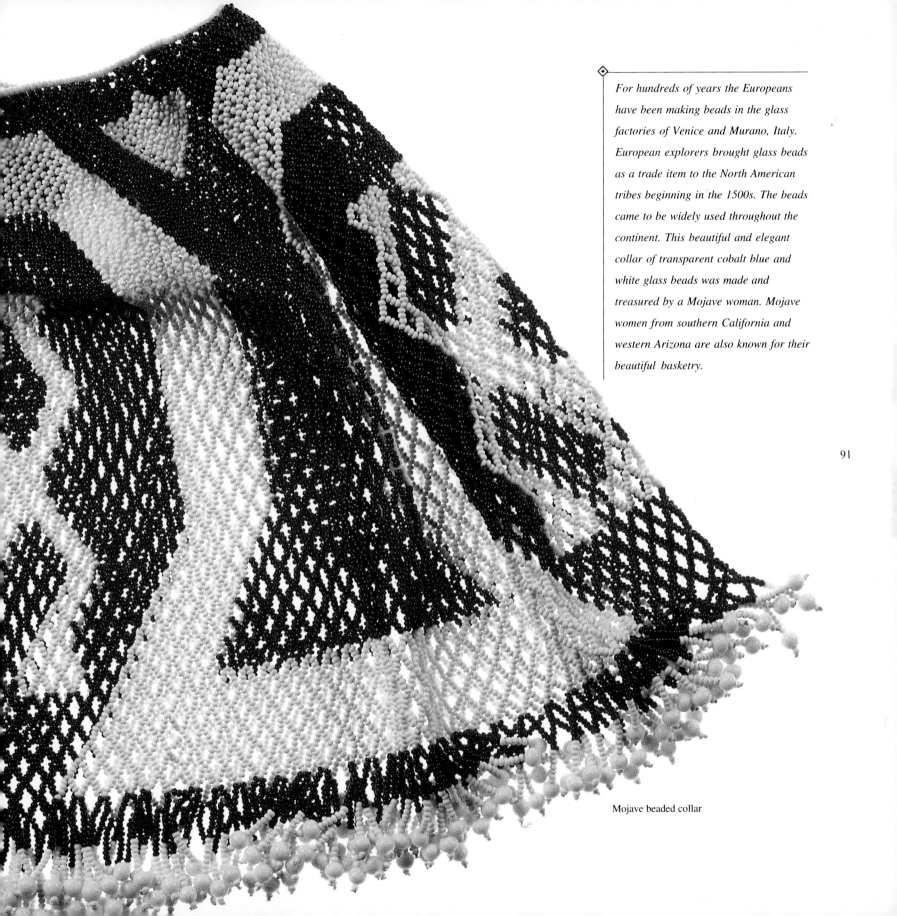

For hundreds of years the Europeans have been making beads in the glass factories of Venice and Murano, Italy. European explorers brought glass beads as a trade item to the North American tribes beginning in the 1500s. The beads came to be widely used throughout the continent. This beautiful and elegant collar of transparent cobalt blue and white glass beads was made and treasured by a Mojave woman. Mojave women from southern California and western Arizona are also known for their beautiful basketry.

Mojave beaded collar

92

Modoc beaded apron

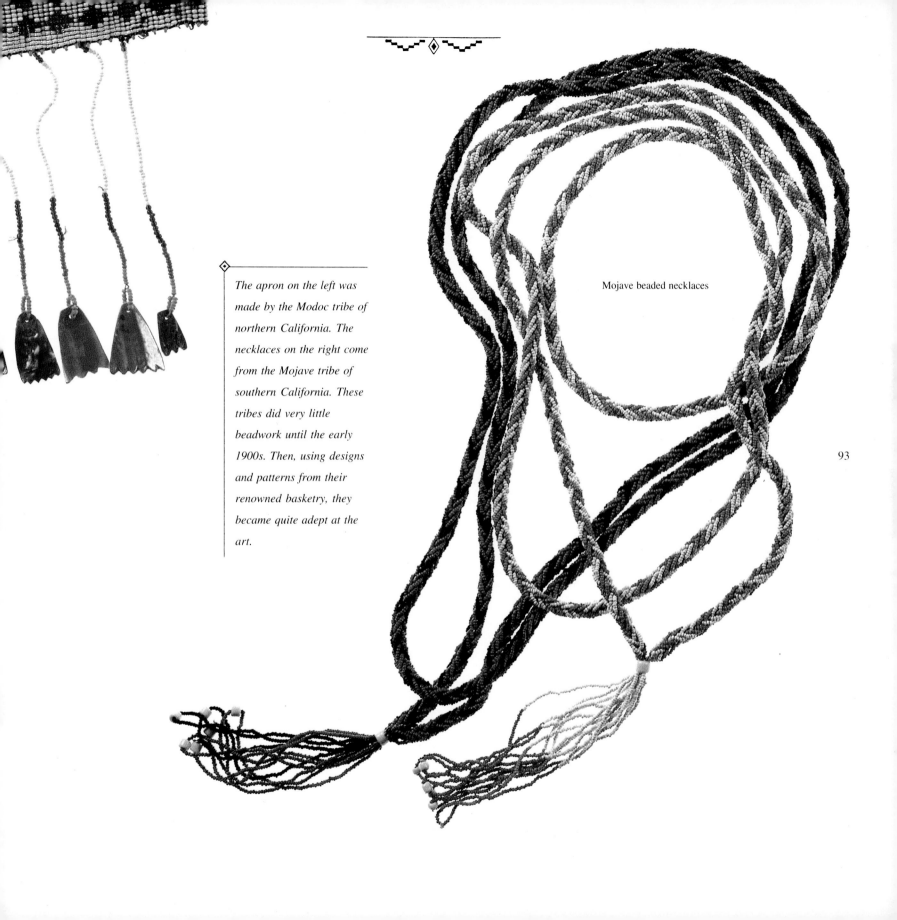

The apron on the left was made by the Modoc tribe of northern California. The necklaces on the right come from the Mojave tribe of southern California. These tribes did very little beadwork until the early 1900s. Then, using designs and patterns from their renowned basketry, they became quite adept at the art.

Mojave beaded necklaces

93

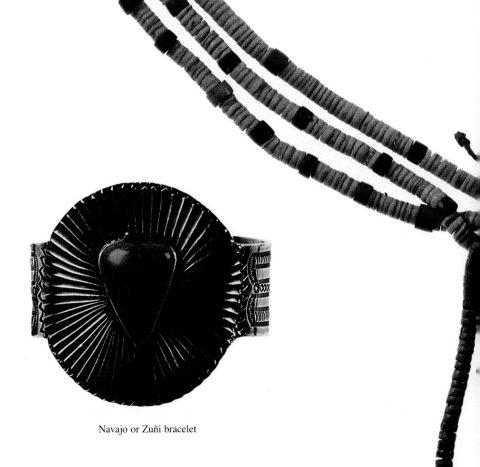

94

The Santo Domingo Pueblo Indians of
New Mexico are known for their fine
clamshell and turquoise hishi beads.
Northern California and Pacific North-
west coastal tribes used clamshells to
make a similar type of hishi called
wampum. Both the Northwest and
Southwest tribes valued their shell
jewelry. Turquoise, another precious
stone, is a gift from Mother Earth to her

Zuñi ring

Navajo or Zuñi bracelet

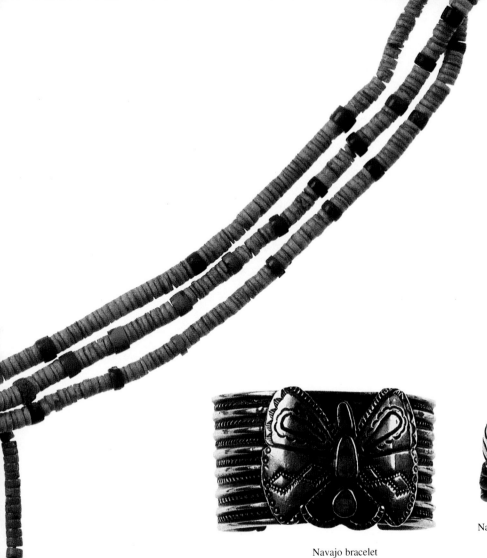

Navajo necklace

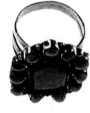

Navajo bracelet

Navajo or Zuñi ring

children of the desert and was worn by all the Pueblo and Navajo tribes. Hanging from the center of the necklace is a pair of earrings, called a jacala. Traditionally the jacala is hung in this manner. Silver was introduced to the Navajo and Pueblo tribes by the Spaniards. Since then, the Navaho and Pueblo people have become fine silversmiths, as shown by the workmanship in these bracelets and rings.

95

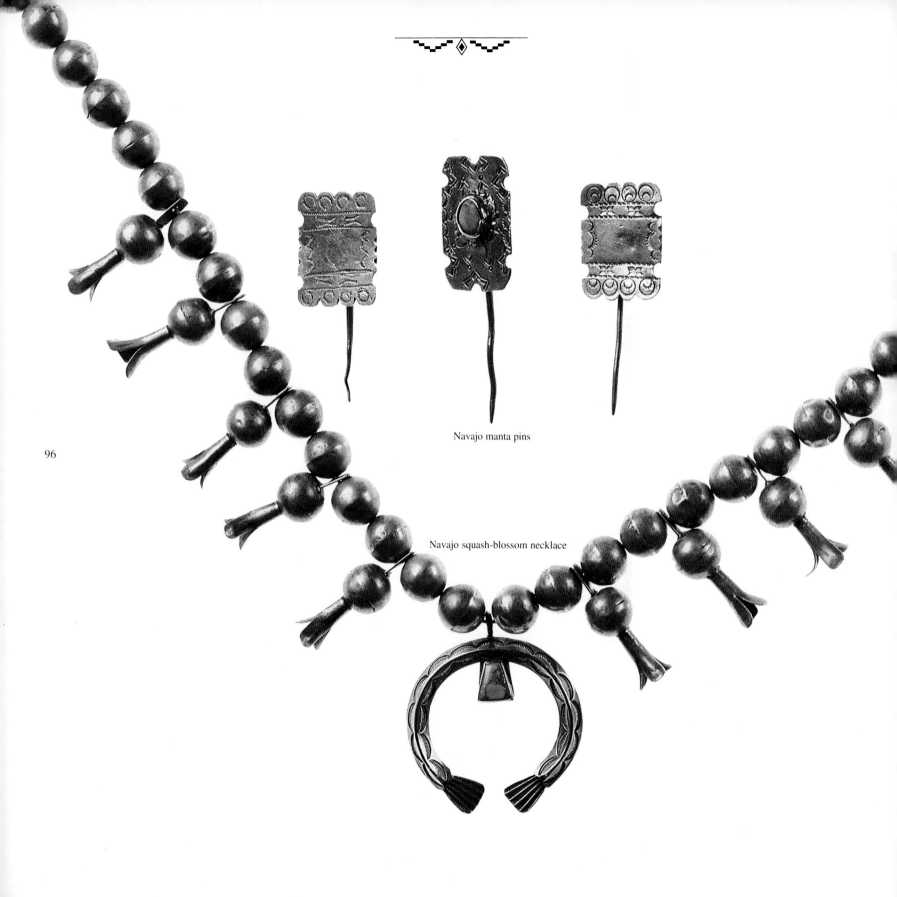

Navajo manta pins

Navajo squash-blossom necklace

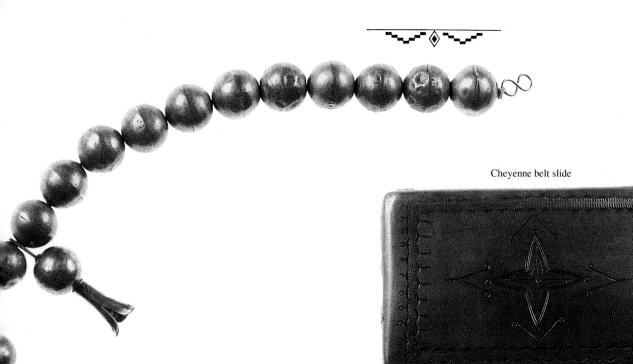

Cheyenne belt slide

When the Spanish conquistadors arrived in the Southwest, their horses had silver bridles with crescent objects hanging from them. These crescents were Moorish symbols. The Navajo tribe borrowed the crescent pattern from the Spaniards and used it on their squash-blossom necklaces; they called the crescent najah. Traditionally worn by a young woman, the squash blossoms on the necklace represent fertility. Silver stick pins (opposite) *were worn by Navajo women to fasten their wearing blankets.*

Navajo manta pin

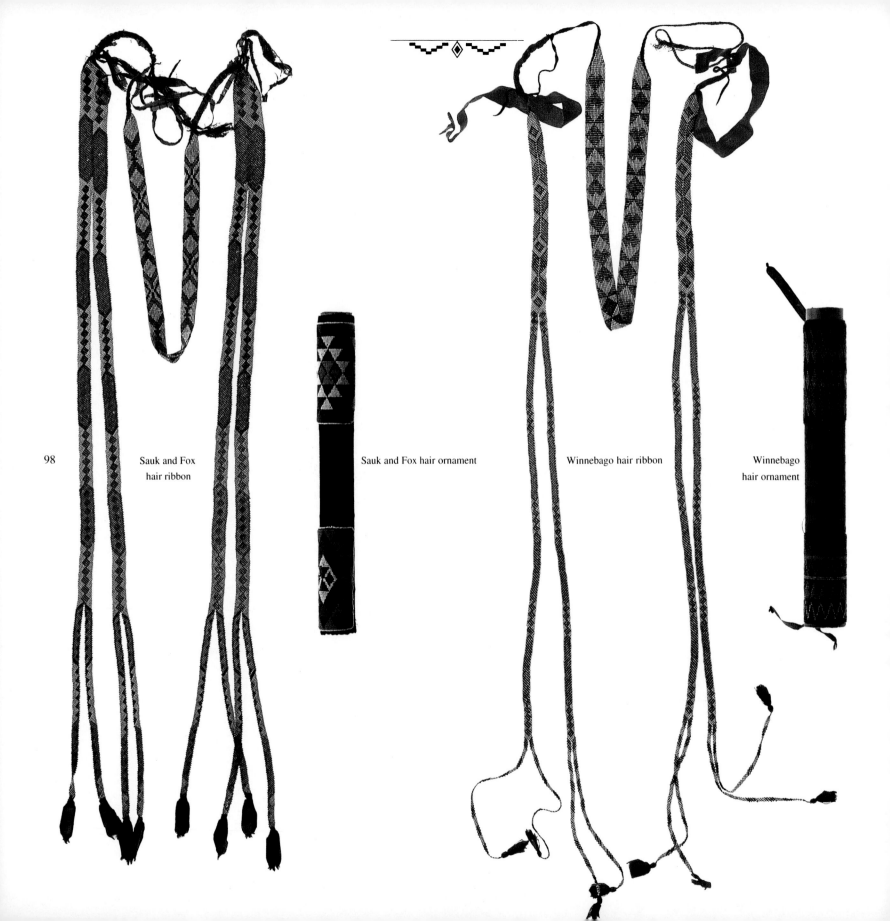

98 Sauk and Fox
hair ribbon

Sauk and Fox hair ornament

Winnebago hair ribbon

Winnebago
hair ornament

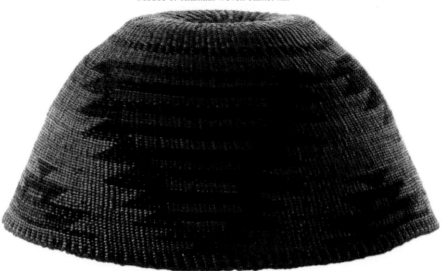

Modoc or Klamath woven basket hat

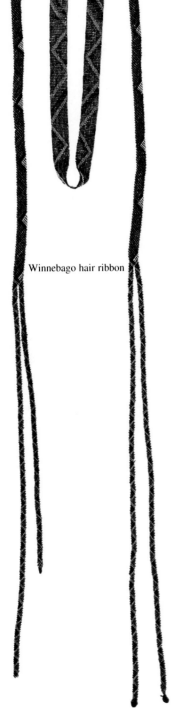

Winnebago hair ribbon

Sauk and Fox hair ornament

Each tribe had its own hairstyle: loose, bobbed, or braided. Most tribes believed that the hair was the outgrowth of the soul. Among the Plains and Intermontane tribes, women bobbed their hair straight across at shoulder length to indicate mourning for a loved one who had passed on to the spirit world. For ceremonial and social gatherings, women would decorate their hair with shells and beaded hair ornaments, and the Columbia Plateau and California Indian women wore basket hats.

99

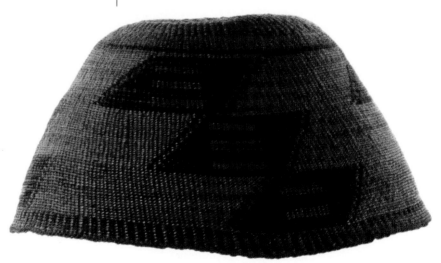

Clallem woven basket hat

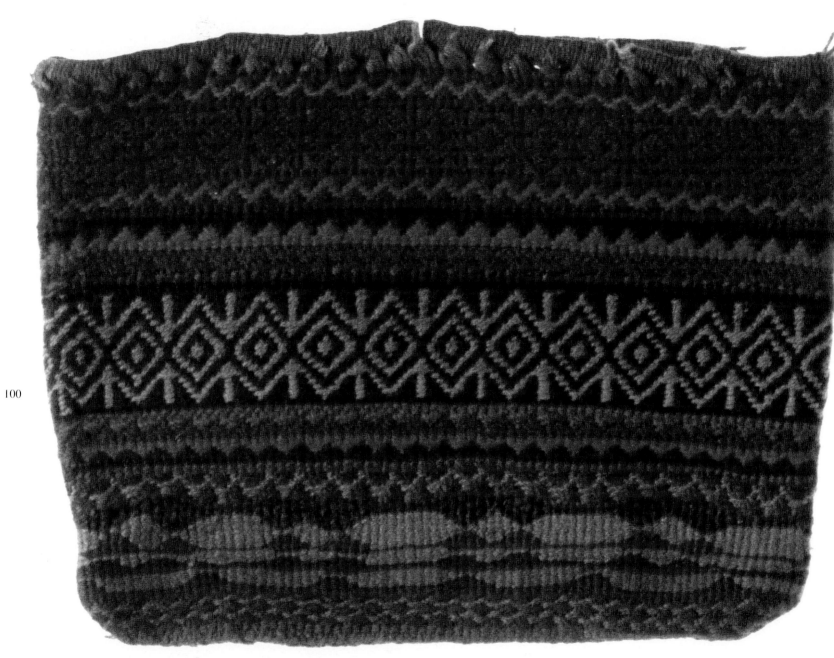

Potawatomi twine yarn bag

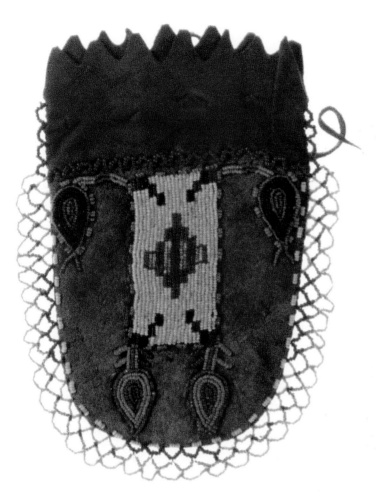

Blackfoot beaded pouch

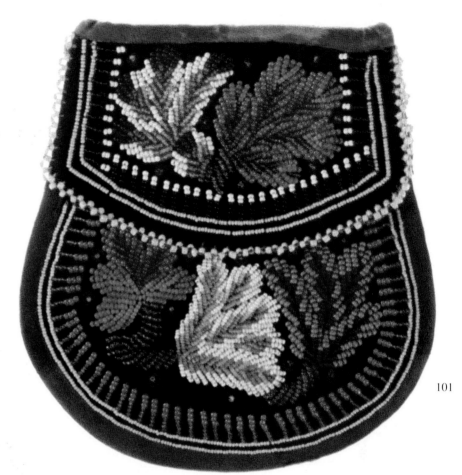

Mohawk beaded pouch

101

Unlike the Plains Indian tribes, the Great Lakes and Eastern Woodland tribes were not nomadic. These tribes remained in one place, where they farmed, hunted, and fished. Women from these regions were known for their floral beadwork on

black velvet. Large woven bags were used for storing household articles and clothing. The beaded pouch with the drawstring is made from a moccasin vamp. Moccasins were cut up and reused, and this type of pouch was common.

▲▲▲

RUNNING EAGLE: WOMAN WARRIOR OF THE BLACKFEET

Our Mother Earth sings
her song of the changing seasons.

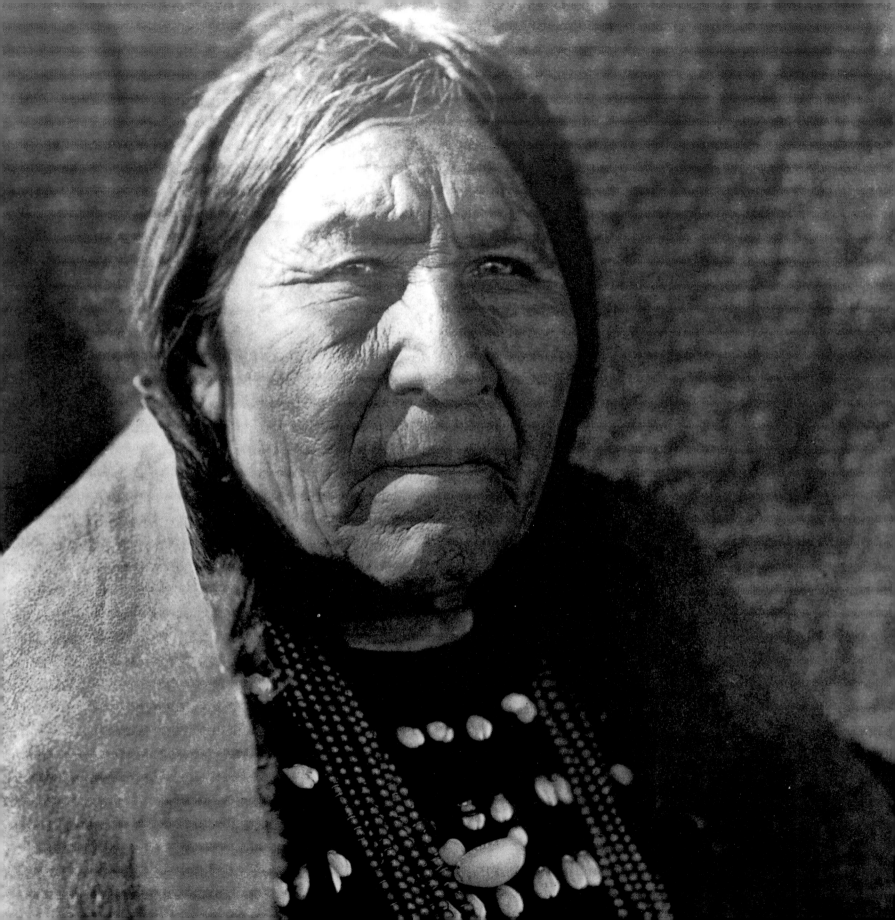

RUNNING EAGLE: WOMAN WARRIOR OF THE BLACKFEET

Visions are sacred to the Plains people. Men or women trying to find their way on the road of life go on a vision quest. The spirit voices tell one what to do and give visions that will determine one's journey in life. Once, a long time ago, a woman took the traditional ways of a man through her vision. She dreamed of becoming a respected, brave warrior. Her dream vision gave her the direction to follow men's ways. She proved her courage time after time and was respected as a great warrior.

Running Eagle has become the most famous woman in the history of the Blackfoot Nation because she gave up the work of the household in exchange for the war trails usually followed by men. In fact, she became so successful on her war adventures that many men called her a chief and eagerly followed her whenever she would take them. She was finally killed during one of her war adventures.

Because this woman died sometime around 1850 the actual facts of her life are now hard to separate from the popular legends. My grandmothers of today still talk about her, and an old book about her life can be found on some library shelves. However, all the stories agree that this woman was very successful in all but her final efforts, and that she was well liked and respected by her people. It is generally believed that she was also a holy woman

Reluctant-to-Be-Woman, Blood-Blackfoot tribe.

who put up Sun Dances, for which she qualified by never marrying or taking a lover in her life. It is said that she pledged herself to Sun, as the result of a vision of power.

The popular story is that Running Eagle began life as an ordinary Blackfoot girl named Brown Weasel Woman. She had two brothers and two sisters, and her father was a well-known warrior. When she became of the age that boys begin to practice hunting, she asked her father to make a set of bow and arrows with which she could practice. He did so, though not without some argument from his wives. It is said that he even allowed her to go with him buffalo hunting, and that she learned to shoot well enough to bring some down.

It was during one of the buffalo hunts with her father that this unusual girl is said to have first shown her warrior's courage. There were only a few Blackfoot hunters in the party, and it was not far from the camps when an enemy war party attacked and chased it. As the people rode toward the camp at top speed, Brown Weasel Woman's father had his horse shot out from under him. One of the bravest deeds performed by warriors in the old days was to brave the enemy fire while riding back to rescue a companion who was left on foot. This is what the daughter did for her father, both of them making their escape on her horse, after she stopped to unload the fresh meat that was tied on behind her. When word of the attack reached the rest of the tribe, a great crowd of warriors rode out after the enemy, killing many of them and chasing the rest away. The young woman's name was mentioned for days and nights after, as the people recounted what had taken place during that particular fight. It is said that some of the people complained, and feared that the girl performing men's deeds would set a bad example which might lead other girls to give up their household ways.

However, when her mother became helplessly ill sometime later, the future warrior woman decided on her own to take up household work. Since

she was the eldest child in the family, there was no one to do the cooking and tanning while her mother slowly withered away. So she worked hard to learn what she had been avoiding, and she taught her younger brothers and sisters to help out wherever they could.

It is hard to say for how many years this young woman took the place of her mother in running the family household, but it is said that she did it very well. However, it is also said that she did it without receiving any pleasure from it, since she had probably already experienced too much excitement from the adventures of men's ways. At any rate, she had no boy friends and she took no interest in the plans others her age were making for marriage.

The turning point in the young woman's life came when her father was killed while on the war trail. News of his death also killed his widow, in her weakened state. The young woman and her brothers and sisters suddenly were orphaned, and she decided at that point to devote herself to her dream power giving her directions to follow men's ways. She took a widow woman into the lodge to help with the household work, and directed her brothers and sisters in doing their share. She even carried a rifle—inherited from her father—at a time when many men still relied mainly on their bows and arrows.

Her first war adventure came not long after she and her family had gotten over their initial mourning. A war party of men left the Blackfoot camps on the trail of Crow warriors who had come and stolen horses. When this party was well under way, one of its members noticed someone following behind, in the distance. It turned out to be the young woman, armed and dressed for battle. The leader of the party told her to go back, threatened her, and finally told her that he would take the whole party back home if she didn't leave them. She is said to have laughed and told him: "You can return if you want to; I will go on by myself."

One of the members of this party was a young man who was a cousin of the young woman—a brother, in Blackfoot relationships—and he offered to take her back himself. When she still refused to go, the leader of the party put this cousin of hers in charge of her well-being, so that they could all continue on their way. She grew up with this cousin, and learned to hunt by his side, so the two got along well, in general.

The war party with the young woman spent several days on the trail before they reached the enemy camps of the Crows. They made a successful raid, going in and out of the camp many times, by cover of night, to bring out the choice horses that their owners kept in front of the lodges. It is said that the woman and her cousin went in together and that she, by herself, captured eleven of the valuable runners. Before daylight they were mounted on their stolen horses and headed back toward their own homeland, driving ahead of them the rest of the captured herd. The Crows discovered their loss in the morning, and chased the party for some way. But the raiders were able to change horses whenever the ones they were riding became worn out, and in that way they soon left the enemy followers way behind.

However, the most exciting part of this first war adventure for the young Blackfoot woman was yet to come, according to the legend that has survived her. While the rest of the party rested and cooked in a hidden location, she kept watch on the prairie country from the top of a nearby butte. From there she saw the approach of two enemy riders, and before she could alert the rest of her party to the danger, the enemies were ready to round up the captured herd. It is said that she ran down the butte with her rifle and managed to grab the rope of the herd's lead horse, to keep the rest from running away. Then, as the enemies closed in on her, expecting no trouble from a woman, she shot the one who carried a rifle and forced the other one to turn and try an escape. Instead of reloading her own rifle, she ran and grabbed the one from the fallen enemy, and shot after the one getting away. She missed him, but others of the

party went after him and shortly brought him down as well. Her companions were quite surprised and pleased at what she had done. Not only had she saved their whole herd from being captured, but she also killed an enemy and captured his gun. She even captured his horse and one of the others took his scalp and presented her with it. It is said that she didn't want it, but she felt better when reminded that she had avenged her father's death.

Although the young woman's first war experience was quite successful, there were still many people who thought that the chiefs should make her stop following the ways of the men. However, the critical talking came to an end altogether after she followed the advice of wise elders and went out to fast and seek a vision. She spent four days and nights alone and the Spirits rewarded her with a vision that gave her the power that men consider necessary for leading a successful warrior's life. Such visions were not always received by those seeking them, and very seldom have women received them at all. By tribal custom, no one questioned her about the vision, nor did they doubt her right to follow the directions which she was thus given. From then on the people considered her as someone unusual, with special powers, whom only the Spirits could judge and guide.

The young woman's second war adventure took her west over the Rocky Mountains, to the camps of the Kalispell tribe. Among her companions were some of the same men who had been on her first war raid, including her cousin/brother, with whom she was spending a lot of her time. This time, instead of wearing her buckskin dress, she had on a new suit of warrior's clothing, including leggings, shirt, and breechcloth. She also carried a fine rawhide war shield, that had been given to her by the man who married the widow woman who had moved into the orphan household some time before.

The second raid turned out quite successfully, although one member of the party was killed. They captured a herd of over six hundred horses, and killed a number of the enemy during a fight which followed their discovery

during the raiding. The young woman was shot at, and would have been killed, but the two arrows both struck her shield, instead of her body.

The next time that the tribe gathered for the annual medicine lodge ceremony, the young woman was asked to get up with the other warriors and tell the people about her war exploits. Other women had done so, but they had usually gone in the company of their husbands and had not accomplished such fearless deeds as she. When she finished her stories the people applauded with drum beats and war whoops, as was the custom. Then the head chief of the tribe, a man named Lone Walker, is said to have honored her in a way never known to have been done for a woman. After a short talk and a prayer, he gave her a new name—Running Eagle—an ancient name carried by several famous warriors in the tribe before her. In addition, the Braves Society of young warriors invited her to become a member, which honor she is said to have accepted as well.

From that point on, Running Eagle, the young woman warrior, became the leader of the war parties she went with, no longer a follower. I cannot say how many such war raids she went on, nor how many horses she captured, nor enemies she killed. There are many different legends about them. There are also legends of men who could not accept that this proud woman wanted no husband, so they tried all the ways known of to make her change her mind about marriage. But the issue was settled when she explained that Sun had come in her vision and told her that she must belong only to him, and that she could not go on living if she broke such a commandment.

As Running Eagle lived by the war trail, so she died also. It was when she led a large party of warriors against the Flathead tribe in revenge for their killing of some men and women who had gone from the Blackfoot camps one morning to hunt and butcher buffalo. The revenge party was a very large one, and she led it right to the edge of the Flathead camp during the night. In the early morning, after waiting for the camp to be cleared of the prize horses by

their herders, she gave the cry to attack. There followed a long drawn-out battle in which many of the enemy were killed. After the initial shooting, the battle turned into a free-for-all in which clubs and knives were the main weapons. Running Eagle was attacked by a large enemy with a club, whom she killed, but another came up behind her and killed her with his club. One of Running Eagle's men in turn killed this man. When the battle was over, the members of her party found her, the large man in front, the other behind, and she dead in the middle. And so ended the career of the woman warrior whose life has become a legend among the Blackfeet.

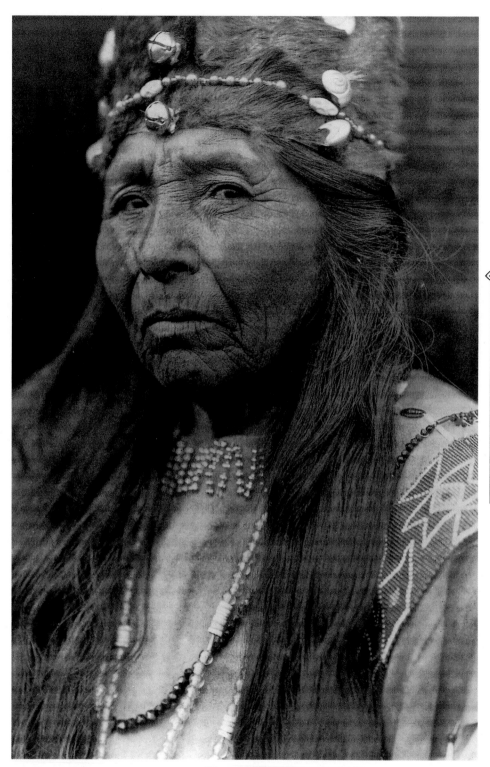

Klamath Woman.

112

I am the mother,
the center of the circle
of my family.

The Earth, our
mother, is the center
of the circle of
our lives.

— ANONYMOUS

Dusty Dress, Kalispell tribe.

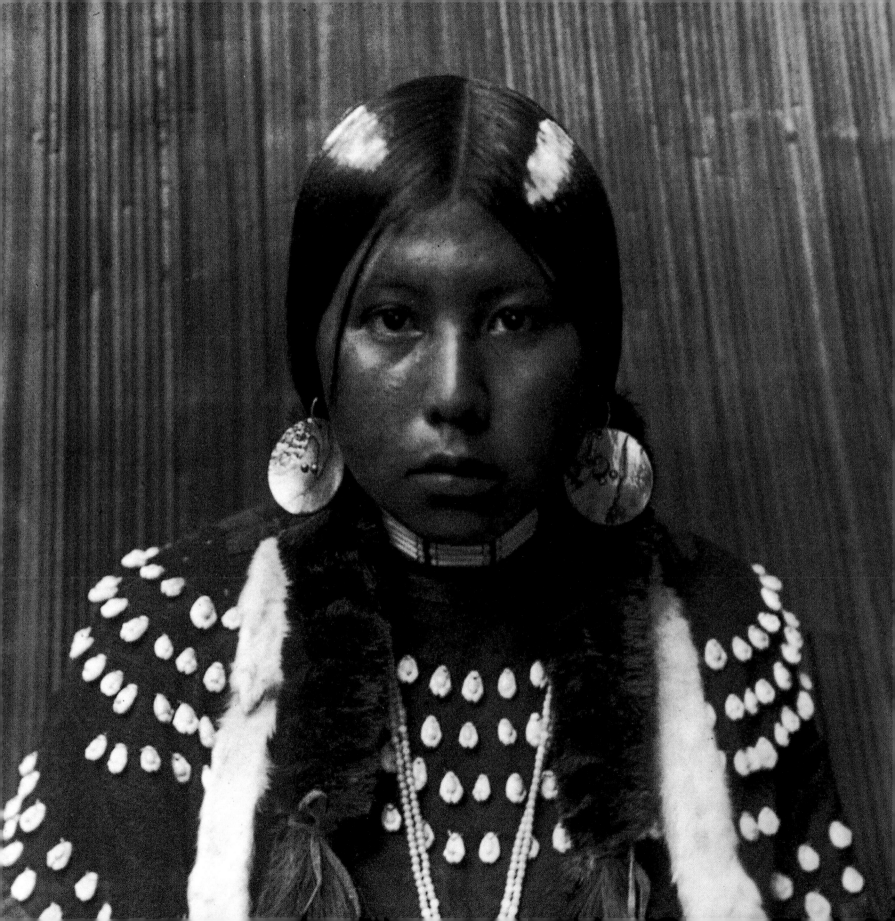

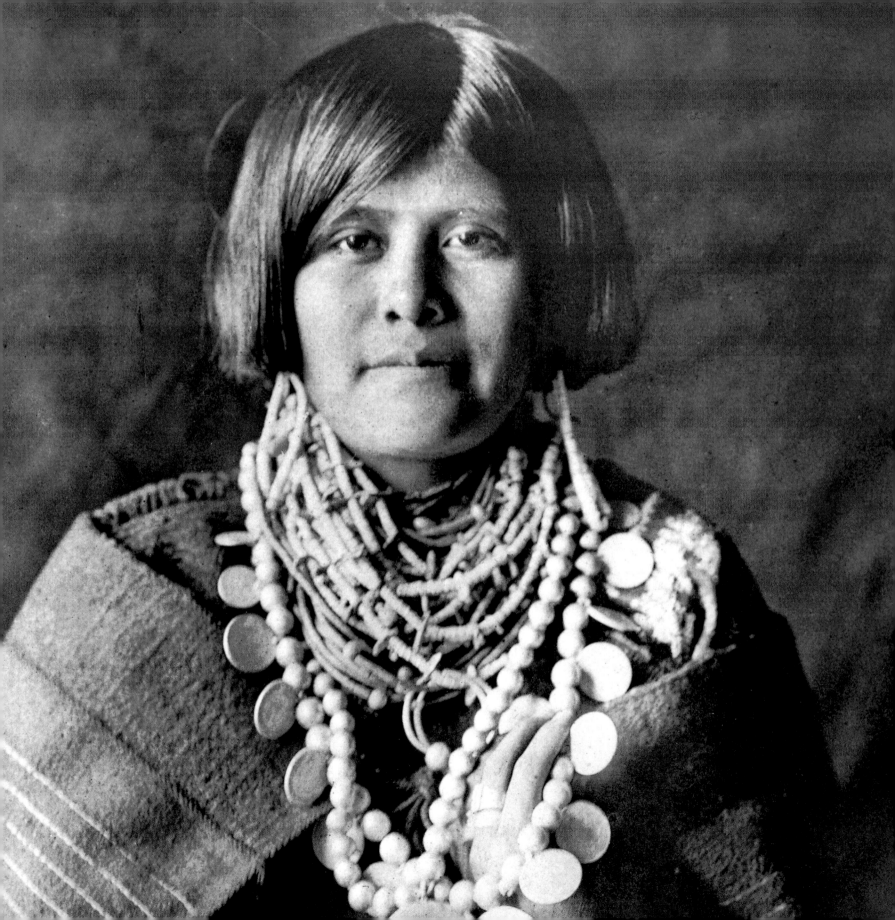

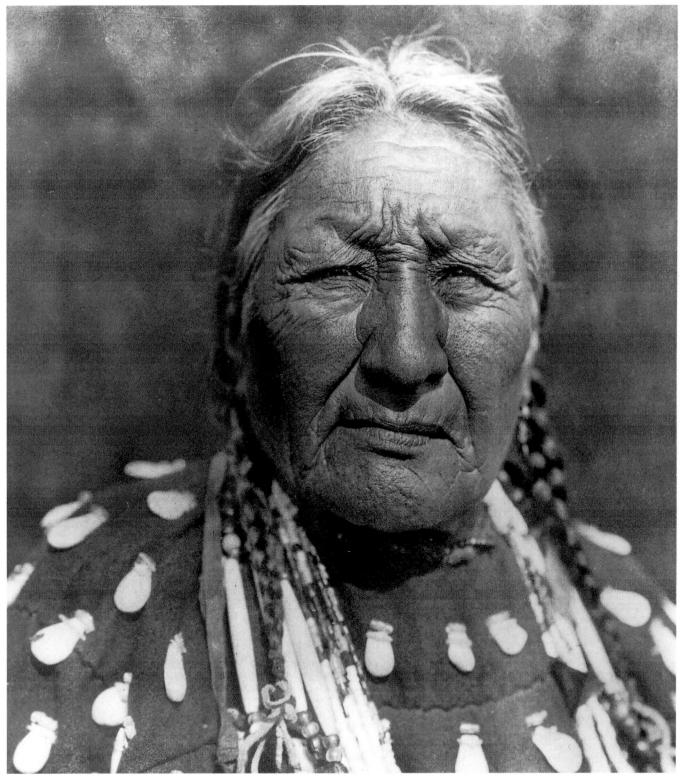

Dog Woman, Cheyenne.

Zuñi girl.

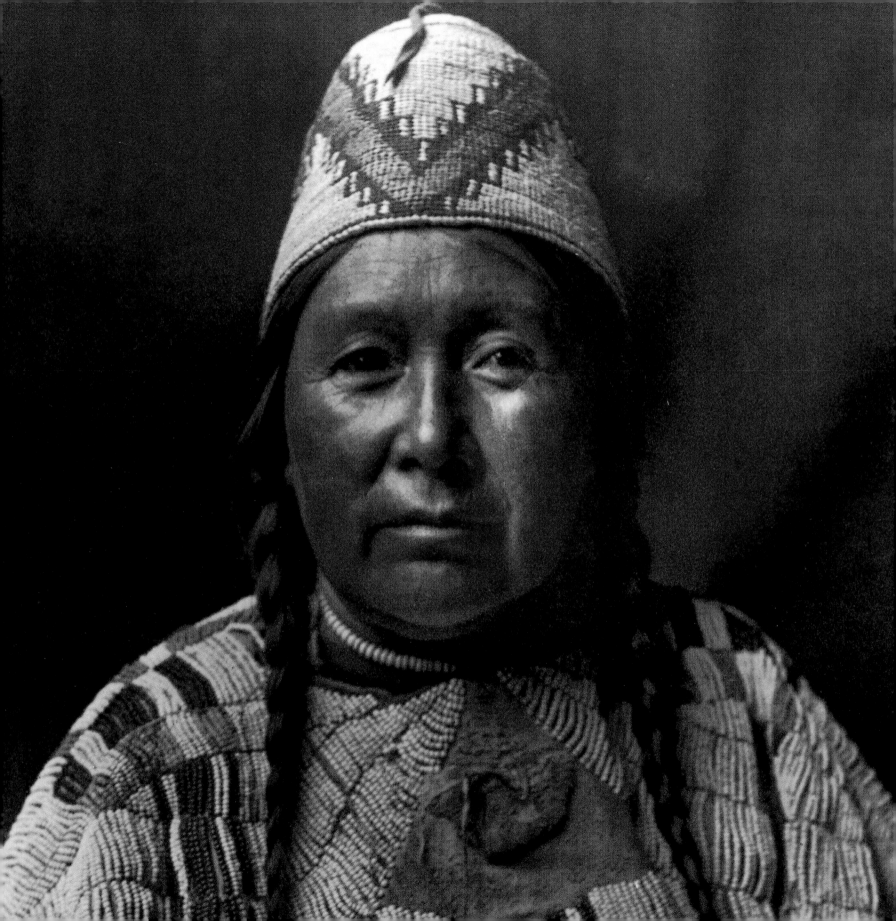

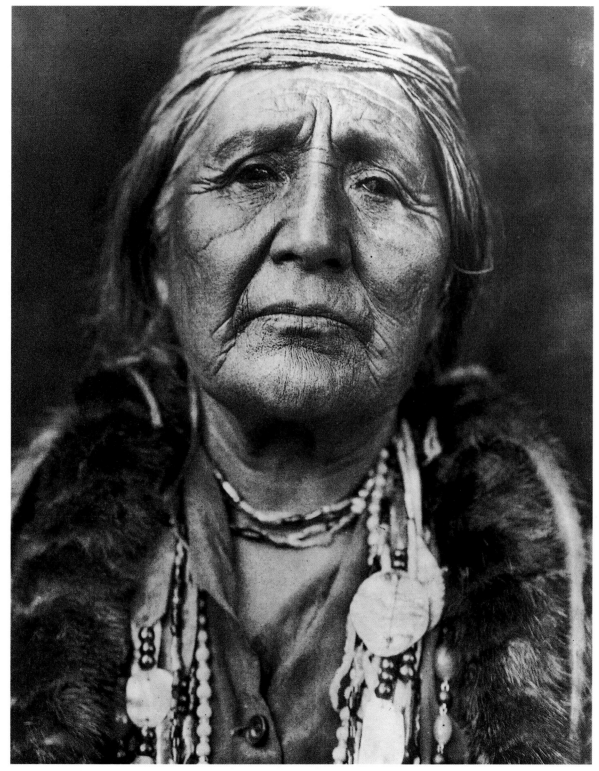

117

Hupa Woman.

Wife of Mnainak, Yakima.

INDEX TO THE ILLUSTRATIONS

Two sources were used for the artifacts in this book: Colter Bay Indian Arts Museum (CBIAM) and the San Diego Museum of Man (SDMM). The artifacts and their museum identification numbers are listed below, in order of the pages on which they appear.

Page	Museum	Identification

Photo credits:

Page 2–3, Maroon Bells-Snowmass Wilderness Area, Colorado, Willard Clay.

Page 4, Swift River, New Hampshire, Willard Clay.

Page 5, *Fiesta of San Estevan — Acoma*, Edward S. Curtis, courtesy of San Diego Museum of Man.

Page 6–7, White Mountains Apache National Forest, Arizona, Willard Clay.

Page 10–11, *A Painted Tipi — Assiniboin*, Edward S. Curtis, courtesy of San Diego Museum of Man.

Page 14, Manatash Creek, Washington, Pat O'Hara.

Page 18, Salt Creek. Canyonlands National Park, Utah, Tom Till.

Page 20, *Mother and Child — Teton Sioux*, Edward S. Curtis, courtesy of San Diego Museum of Man.

Page 25, *A Hopi Mother*, Edward S. Curtis, courtesy of San Diego Museum of Man.

Page 36, San Isabel National Forest, Colorado, Willard Clay.

Page 38, Two Cheyenne girls, photographer unknown, courtesy of San Diego Museum of Man.

Page 58, Illinois Canyon, Starved Rock State Park, Illinois, Willard Clay.

Page 60, *A Piegan Play Tipi*, Edward S. Curtis, courtesy of San Diego Museum of Man.

Page 63, Admiralty Island National Monument, Alaska, Pat O'Hara.

Page 76, Badlands National Park, South Dakota, Willard Clay.

Page 78, *Wishham Bride*, Edward S. Curtis, courtesy of San Diego Museum of Man.

Page 102, Chisos Mountains, Big Bend National Park, Texas, Willard Clay.

Page 104, *Reluctant-to-Be-Woman — Blood*, Edward S. Curtis, courtesy of San Diego Museum of Man.

Page 112, *Klamath Woman*, Edward S. Curtis, courtesy of San Diego Museum of Man.

Page 113, *Dusty Dress — Kalispel*, Edward S. Curtis, courtesy of San Diego Museum of Man.

Page 114, *A Zuñi Girl*, Edward S. Curtis, courtesy of San Diego Museum of Man.

Page 115, *Dog Woman — Cheyenne*, Edward S. Curtis, courtesy of San Diego Museum of Man.

Page 116, *Wife of Mnainak — Yakima*, Edward S. Curtis, courtesy of San Diego Museum of Man.

Page 117, *Hupa Woman*, Edward S. Curtis, courtesy of San Diego Museum of Man.

For further information, contact the museums at the addresses listed below:

Colter Bay Indian Arts Museum
Colter Bay Visitor Center
Grand Teton National Park, Wyoming 83012

San Diego Museum of Man
1350 El Prado, Balboa Park
San Diego, California 92101

BIBLIOGRAPHY

Akwesasne Notes. *A Basic Call to Consciousness*. New York: Akwesasne Notes, 1978.

Armstrong, Virginia. *I Have Spoken: American History Through the Voices of the Indians*. Chicago: The Swallow Press, 1971.

Beck, Peggy V., and Anna L. Walters. *The Sacred: Ways of Knowledge, Sources of Life*. Tsaile, Ariz.: Navajo Community College Press, 1977.

Black Elk. *The Sacred Pipe: Black Elk's Account of the Seven Rites of the Oglala Sioux*. Edited by Joseph Epes Brown. Norman: University of Oklahoma Press, 1953.

Brown, Dee. *Bury My Heart at Wounded Knee*. New York, Chicago, San Francisco: Holt, Rinehart, and Winston, 1977.

Brown, Joseph E. *The Spiritual Legacy of the American Indian*. New York: Crossroads Publishing Company, 1986.

Davis, Barbara A. *Edward S. Curtis: The Life and Times of a Shadow Catcher*. San Francisco: Chronicle Books, 1985.

Densmore, Frances. *Teton Sioux Music*. Bulletin no. 61. Washington, D.C.: Bureau of American Ethnology, 1918.

Farr, William E. *The Reservation Blackfeet 1882–1945, A Photographic History of Survival*. Seattle and London: University of Washington Press, 1984.

Gard, Wayne. *The Great Buffalo Hunt*. Lincoln and London: University of Nebraska Press, 1968.

Hoig, Stan. *The Sand Creek Massacre*. Norman: University of Oklahoma Press, 1961.

Houlihan, Patrick, Jerold L. Collings, Sarah Nestor, and Jonathan Batkin. *Harmony by Hand: Art of the Southwest Indians*. San Francisco: Chronicle Books, 1987.

Howard, Helen Addison. *Saga of Chief Joseph*. Caldwell: The Caxton Printers, Ltd., 1971.

Hungry Wolf, Adolf. *Children of the Sun*. New York: William Morrow and Company, Inc., 1987

Hungry Wolf, Beverly. *The Ways of My Grandmothers*. New York: William Morrow and Company, Inc., 1980.

Hyde, George. *Red Clouds Folks: A History of the Oglala Sioux*. Norman: University of Oklahoma Press, 1937.

Jones, Douglas C. *The Treaty of Medicine Lodge*. Norman: University of Oklahoma Press, 1966.

Josephy, Alvin M., Jr. *The Nez Perce Indians and the Opening of the Northwest*. New Haven and London: Yale University Press, 1965.

Kroeber, Theodora. *Ishi*. Berkeley and Los Angeles: University of California Press, 1964.

Laubin, Reginald and Gladys. *The Indian Tipi: Its History, Construction and Use*. Norman: University of Oklahoma Press, 1984.

Lowie, Robert H. *The Crow Indians*. Lincoln and London: University of Nebraska Press, 1963.

Lyford, Carrie A. *Quill and Beadwork of the Western Sioux*. Boulder: Johnson Publishing, 1990.

Marriott, Alice. *The Ten Grandmothers*. Norman: University of Oklahoma Press, 1977.

McLuhan, T.C. *Touch the Earth: A Self-Portrait of Indian Existence*. New York: Outerbridge and Lazard, 1971: Simon and Schuster, Pocket Books, 1972.

Miller, David Humphrey. *The Ghost Dance*. New York: Van Rees Press, 1959.

Neihardt, John G. *Black Elk Speaks*. Lincoln and London: University of Nebraska Press, 1989.

Nevin, David. *The Soldiers*. New York: Time-Life Books, 1973.

Niethammer, Carolyn. *Daughters of the Earth: The Lives and Legends of American Indian Women*. London: Collier MacMillian Publishers, 1977.

Rockwell, David. *Give Voice to Bear: North American Indian Myths, Rituals and Images of the Bear*. Niwot: Robert Rinehart Publishers, 1990.

Roe, Frank Gilbert. *The Indian and The Horse*. Norman: University of Oklahoma Press, 1974.

Stewart, Omer C. *Peyote Religion: A History*. Norman and London: University of Oklahoma Press, 1990.

Trenholm, Virginia Cole, and Maurine Carley. *The Shoshoni's Sentinels of the Rockies*. Norman: University of Oklahoma Press, 1964.

Vestal, Stanley. *Sitting Bull: Champion of the Sioux*. New York: Houghton Mifflin, 1932.

Voget, Fred W. *The Shoshoni-Crow Sun Dance*. Norman: University of Oklahoma Press, 1984.

Walters, Anna Lee. *The Spirit of Native America: Beauty and Mysticism in American Indian Art*. San Francisco: Chronicle Books, 1989.